ORIENTAL RUGS

AN INTRODUCTION

GORDON REDFORD WALKER

PRION

To the merchant importers in London, gentlemen all.

And for my handmaidens in Bath… Al, Amanda, Dorothy, Helen, Jill, Jenny, Kathy, Kay, Kristina, Liz, Pauline, Peggy, Sheelagh and Verity. And Louise who typed it.

This paperback edition published in 2001 by
Prion Books Limited,
Imperial Works,
Perren Street,
London NW5 3ED
www.prionbooks.com

First published in 1999

ISBN 1-85375-430-7

Cover design by Bob Eames
Printed and bound in Singapore

ORIENTAL RUGS

AN INTRODUCTION

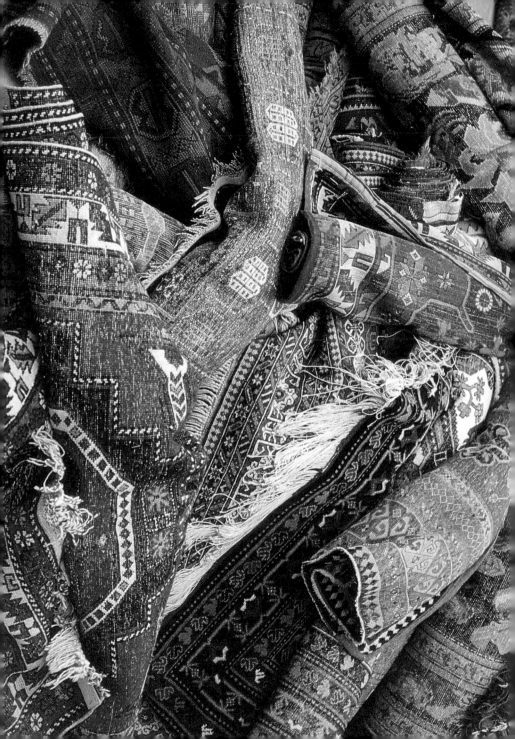

INTRODUCTION

WHAT every reader of a book such as this seeks is what no such book can hope to provide: the ability, after a few hours' reading, to identify and evaluate any Oriental rug at the drop of a hat.

The field is vast, the range of qualities and types virtually inexhaustible. All that can be hoped is that readers will acquire an approach, a methodology to help them to narrow the range, to form a reasonable assessment of what a particular rug might be, and to have some appreciation of its antecedents and origins. This being the objective, the book deals deliberately in wide generalisations and it follows that some of what is written here will be controvertible by specific example.

There never was a field of information to which the cliché of the exception proving the rule could be more aptly applied: half the fascination in Oriental rugs lies in their quirks, inconsistency and unpredictability. It is essential to remember that we are dealing with an art form: passionate, erratic, creative, sometimes random, sometimes disciplined – always inconsistent.

There is absolutely no alternative to spending considerable time at auctions and in shops to develop your own 'feeling' for the subject, and the word should be taken literally. Getting your eye in is important but is only half the knack: the fingertips have also to learn, to develop a 'feel' for texture,

Opposite: A pile of rugs rolled up for transport to market, Azerbaijan.

so that they can contribute a tactile dimension to any assessment. There is also an extensive vocabulary which comes with the world of Oriental rugs. Names and terms have been grouped and explained to help a newcomer with the specifics and the pronunciation of more difficult words is indicated in italics.

Black and white illustrations have been used in places to enable readers to concentrate on visual elements without the distraction of colour. To make the book useful in another dimension, however, to interior decorators and to those seeking help with particular colour schemes, we have incorporated a unique colour analysis. By looking up the colour groups that interest you and cross-referring them to the rug types you can then read about that sort of rug, find out if it is likely to be available in the size that you want, and discover whether or not it is likely to be in your price range. Prices quoted are intended to reflect the approximate retail price in 1999 nett of tax.

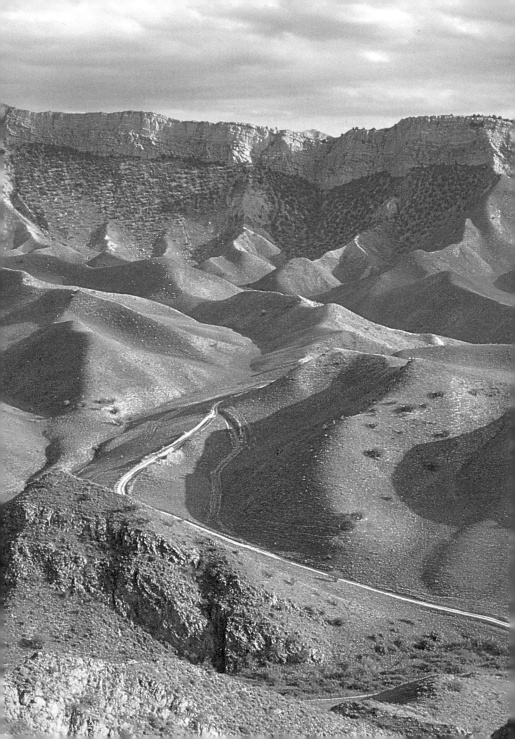

THE VOCABULARY OF RUGS

THE subject of Oriental rugs is nothing if not colourful, both literally and metaphorically. Enthusiasts employ a very special language to describe and communicate the qualities they find in the rugs. This language, the very place-names, and terms descriptive of function, design, structures, sizes and shapes is to Western ears evocative and romantic.

Opposite: The mountain ranges of Kopetdag National Park, Turkmenistan.

RUGS NAMED ACCORDING TO GEOGRAPHICAL SOURCE

A basic grasp of the geography of the areas involved in the study of Oriental rugs is fundamental, because most are named for their geographical origin. Thus an Ispahan (*essfahan*) is so called because it was made in the city of Ispahan in Central Iran, the well-known Bokhara comes from the Turkmenistan region of Southern Central Russia, of which Bokhara is the market town; Hamadan, perhaps the most common of all, are made in 700 villages surrounding Hamadan in Central Western Iran.

Others, more poetically, bear descriptive names, such as the cherished Daghestan (*daggesstan*), which comes from the shores of the Caspian Sea – the name translates as 'place of the mountains'.

STRUCTURAL TERMS

Above: A typical Ghilim.

Opposite: 'Fringes'.

KILIM/GHILIM (*gilleem*)

These are made of a flat-woven fabric, as opposed to 'knotted' and have no 'pile'. They are produced in most of the centres where rugs are made, hence you will come across Afghan ghilims, Anatolian ghilims, and so forth. Earlier this century they were used with nonchalant disregard to wrap or bale the knotted, more prestigious rugs for shipping. Not so today, however – some rare old examples fetch very high prices.

SOUMAK (*soomak*)

A soumak is like a ghilim in that it is flat-woven, but it is also embroidered and the embroidery threads are not cut off at the back. The soumak is therefore characterised by a shaggy, erratic collection of loose ends or strands of wool on the back.

BAFF

This word literally means 'knot' and appears in terms such as 'Farsibaff' meaning made with the Persian or Senneh knot q.v. or 'Turki-baff', the Turkish knot q.v.

'FRINGES'

Fringes do not exist as such. What you see at the top and bottom of rugs are the ends of the warps running throughout the rug from north to south; they are

therefore an integral part of the rug. Their treatment varies
according to the whim of the weaver from one rug to another
and the same rug even, quite commonly, is different at the
north end from the south end. They often wear down as a
result of neglect or misuse, and cannot, or rather, would not
be replaced by the purist with any type of machine-made
tasselling.

PILE

Most oriental rugs consist of 'knotted' pile, which is
discussed in detail later. It is important to realise that
'knotted' is a misnomer. A 'knot' in our vocabulary is a
filament interwound with itself and then pulled tight into a
locking position: the 'knots' in oriental rugs are convoluted
loops, cut off to leave loose ends or 'pile' on the front of the
rug.

SELVEDGE

This is the term applied to the sides of a rug, east and west.
It consists either of several warps bound together with
overcasting or a thicker piece of yarn or rope sewn on to the
edge to firm up the margin and protect the 'knotting'. If a
piece works loose therefore, it is easily fixed and of no great
significance in terms of the rug's value. Missing or broken
knotting in the body of the rug is of more serious concern.

SIZES AND SHAPES

Genuine Oriental rugs are rectangular in shape with rare exceptions. Ninety-nine per cent of circles and ovals come only in 'commercial' goods – Chinese and Indian.

Oriental rugs come in basic graduated steps approximately as follows:

3 x 2 feet or less (known as a Pushti (*pooshtea*), meaning pillow sized)

5 x 3 feet (known as a Zaronym (*zaroneem*) from the Persian measurement zar; this size is a zar and a half)

6 x 4 feet

7 x 5 feet (known as a Dozar (*doughzar*), meaning two zars)

9 x 6 feet and

12 x 9 feet

There are wide variations in special pieces thereafter, notably the useful **keley** (*kellay*), at about 12 x 4 feet up to 16 x 6 feet. The keley was originally part of a formal layout of carpets used for receptions as illustrated on the next page.

The **Keleghi** (*kellayhee*) is at the head: **Kenareh** (*kenarray*), picturesquely, means 'seashore' or 'river bank'.

Runners, or 'strips' as they are called by some in the trade, are rarely narrower than 2 feet 6 inches or shorter than 9 feet.

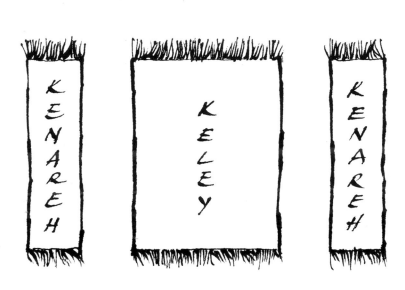

Above: Layout for a formal reception (see p.15).
Opposite: A prayer arch.

Terms relating to function

Prayer Rug

A common misconception is that prayer rugs are small. Some are actually quite big, but the distinguishing characteristic of a prayer rug is that it has a prayer arch at one end only, the Mihrab (*meerab*).

The prayer arch at one end makes the rug clearly visually directional, with a top and bottom, relating obviously to its function; it is laid on the ground with the arch pointing to Mecca and knelt upon for prayer, five times a day if the Koran's precepts are faithfully followed.

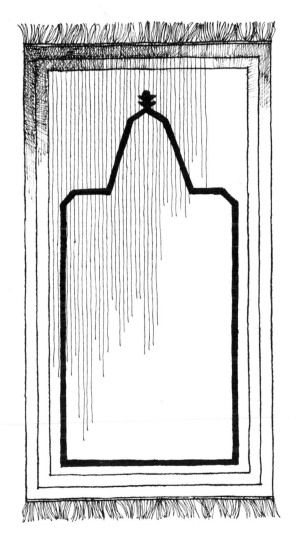

Above: A saph with a prayer arch for each member of the family.

SAPH (*saff*)

A term used to describe a communal prayer rug in Turkey. The saph has a prayer niche for each member of the family.

ENGSI (*ensee*)

Opposite: An Engsi.

This was not originally used for the floor at all; it was a door hanging, used in the doorway of a Turkoman tent. The tent was a semi-permanent igloo affair with a timber frame, the 'rug' with cruciform pattern illustrated is referred to as hatchli (*hatchloo*) which is the Russian word for a cross. This pattern derived from an attempt to emulate the panels in timber doors which the tribes people had seen in the city.

CHUVAL (*chooval*)

This is a Turkoman term. The chuval is actually one side of a bag, and not a rug at all, originally made for the transportation of goods and chattels by camel or horse. They are mostly about 4 x 3 feet. (see p.20)

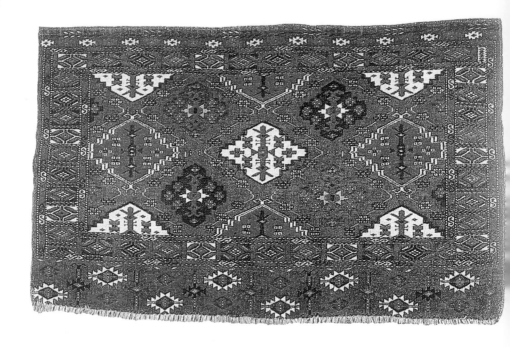

Above: A
Chuval.

HALI (*halee*)

This comes from the Turkoman term meaning main carpet i.e. the one in the middle of the tent floor. It measures about 12 x 9 feet and is usually put out on special occasions.

SIZE, FUNCTION AND SOURCE COMBINED

Articulated names can arise where a piece is given a functional name and is also named for a geographical area, or a tribe. Thus you can meet an Ispahan dozar, which simply means an Ispahan measuring about 7 x 5 feet, or a Tekke Bokhara, which is a Turkoman carpet made by the Tekke tribe. Such terms are perfectly authentic – indeed more correct than simply saying 'Bokhara' which is less informative.

TERMS RELATING TO QUALITY

Over the years, a variety of terms relating to quality have come into use. For example, the Belouch (*baylooch*) from Meshed (*meh-shed*) in Iran are generally more densely knotted than those from Herat in Afghanistan. Thus you may come across a Meshed Belouch although, being nomadic in origin, you could not be sure that it actually came from Meshed. It is a rule of thumb.

'MORI' BOKHARAS

A corruption of the term 'Mauri' which meant higher or finer quality; now it is mostly used to refer to Pakistan bokharas which are certainly inferior, however, to the Russian originals.

Below: a boteh motif.

MOTASHEM

Used in conjunction with Kashans (see p.64) made in the early 20th century from merino wool: a Motashem Kashan is notably more velvety in pile than its sisters.

LAVER.

A term applied to some Kermans, and very occasionally Tabriz (see p.56). A mis-transliteration of 'Ravar', a village north of Kerman, it is loosely used in the trade to indicate either an older Kerman or an unusually good (fine) one.

BIBIBAFF.

Applied to top quality Bachtiari (see p.91). The term literally means knot (*baff*), of the first wife (*bibi*) – the first (and oldest) wife was assumed to be the best weaver, by dint of experience.

TERMS RELATING TO VISUAL FEATURES

BOTEH (*boatay*)

These are a repeating motif in the configuration of a teardrop, the forerunner of the Paisley pattern.

GULS (*gools*)

These are 'flower heads' – a stylised motif most commonly used in a regimented, repeated pattern, sometimes loosely (and unhelpfully) referred to as 'the elephant's foot' design.

HERATI

This pattern is a widely used and ancient motif, variously interpreted as portraying vine leaves or fish, found both in the main field and as a border decoration (see Ferraghan p.85).

Left: the herati motif.

Below: Detail of a herati pattern in a carpet.

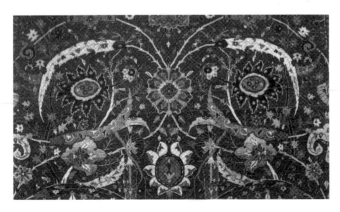

MEDALLION

Many Oriental rugs have a central visual statement, a clearly
defined element in the centre of the 'field' referred to as the
'medallion'.

POLE MEDALLION

This refers to an extended central motif, whose elements are
sometimes connected with a central line.

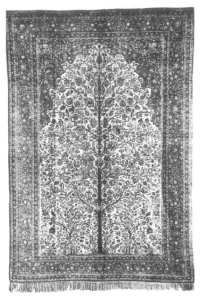

*Left: The
Tree of Life
motif.*

*Far left:
Spandrels.*

SPANDREL
This term refers to decorated corners.

TREE OF LIFE
A central south to north symbol frequently found in prayer
rugs, interpreted by some as Shamanic or Totemic, and by other
more poetically inclined observers as symbolising the vital
connection between paradise above, the world in which we live,
and the world 'below'.

ABRASH

This refers to a faint or strong variation in the hue of the colour of the wool, a sudden alteration from dark blue to pale blue for example, or red to rose, bearing no relationship to an alteration in pattern or delineation of design. It may result either from the use of a fresh batch of wool in which the dye has taken differently or the careless use of the wrong skein of wool from those at the weaver's elbow. Many welcome its presence, believing that it adds dimension or perspective in terms of colour, rather than thinking of it as a flaw. After all, Oriental rugs are full of 'flaws' and 'faults' – and therein lies a large part of their fascination.

BORDERS

Also known by some in the trade as 'guard stripes', borders are simply the frame of the picture. It is a common misconception that the best rugs have seven guard stripes, or that the more guard stripes a rug has the better it is. What is important is that the scale of the border or borders should be in proportion to the field, and visually in step with the overall effect. Some borders are very beautiful in themselves, actually adding a different visual theme and another dimension; this is a bonus.

Patina

This is a term much bandied about by amateurs. A rug will only develop true patina if it was originally made with vegetable dyes: the hues in these dyes are imperfectly applied and unstable in varying degrees. Exposure to light mellows the hues and traffic polishes the pile; the combined result is 'patina'.

Washed or super washed

All Oriental rugs are washed to settle the dyes. Those that reach the West other than through legitimate trade channels escape a final washing in Europe and this is evident in their curiously stiff, board-like consistency.

The term 'washed' as in 'washed Chinese' or 'washed Afghan' that you will come across in the shops is another matter entirely. What it means is that the colours have been heavily bleached to reduce their intensity so making them easier on the eye and giving them the appearance of being older. 'Golden' Afghans all start out in life as pillar box red; the gold results from a bleaching procedure which reduces the life of the rug, but only by about 10 per cent or so. It is fairly easy to see the original red if you open the pile across the front. A distinct pink or russet colour is still visible in the roots of the knots.

SIGNATURES AND DATING

SIGNATURES

Some relatively rare rugs are signed by the master weaver
from whose workshop (*atelier*) they came, usually in a little
panel put there for the purpose.

However, many classical patterns are now copied, notably in
India, by illiterate people, so that you may find a poor-quality,
brand new rug bearing a proud signature, the maker having
mistaken it for part of the pattern.

*Opposite: A
panel of
knotted pile on
the bottom
fringe carries
the signature.*

DATES

These sometimes appear intentionally and sometimes
accidentally for the same reason as signatures. To convert a
genuine date from the Hejira calendar to the Gregorian, deduct
3 per cent and add 622. Beyond this, however, the dating of
Oriental rugs and carpets, except perhaps by carbon analysis, is
far from an exact science, even where 'experts' are at work. It is
based mainly on an assessment of condition with particular
regard to corrosion of the pile where black die was used, and
the impact of the hues of the other colours on a practised eye.
These and other criteria may be used by the best experts in
dating a piece to the nearest twenty or thirty years.

If a date is actually woven into the fabric, and its
interpretation is of critical importance, beware of forgery.
Indeed, one celebrated observer says he has never seen a dated
Turkoman that is genuinely dated: obviously the second digit is
the favourite to tamper with, since substituting '2' for '3' or '1'
for '2' can make a piece 97 years older. Scrutinise the wool and

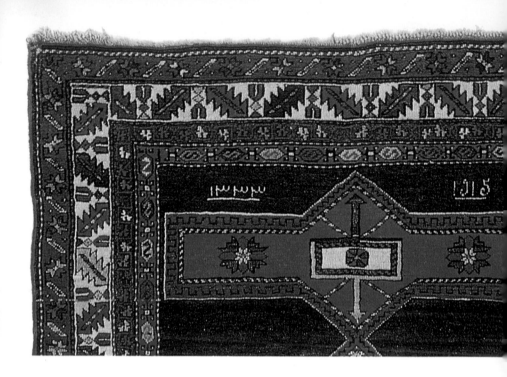

*Above: A
Caucasian rug
displaying the
date 1915 in
Hejira on the
left and
Gregorian on
the right.*

the knotting where the numbers appear.

When you get out there among the rugs and the dealers, you will come across terms like 'old', 'antique' and 'modern' and you may wonder exactly what they mean. 'Antique', used by responsible traders, is understood to mean at least a hundred years old, as with furniture. 'Old' usually means around sixty to a hundred years old. 'Modern', means less than twenty years old – probably new or at least unused.

Study any Oriental rug and you will find all sorts of elements in its design which simply do not balance. An appearance of symmetry is achieved by a group of assymetrically

arranged elements. But don't fall for the old story about the weaver making deliberate mistakes because only Allah is allowed to be perfect; very few Oriental rugs, even city pieces of the highest quality will stand up to more than a two-minute search for erratic design elements.

The vast majority will reveal charming inconsistencies immediately; the creators of oriental rugs are simply not interested in symmetry. They fling down their vivid designs with the same careless abandon as that with which an accomplished painter splashes paint on his canvas.

Below you can see the Islamic/Arabic numerals you are likely to meet in the study of Oriental rugs.

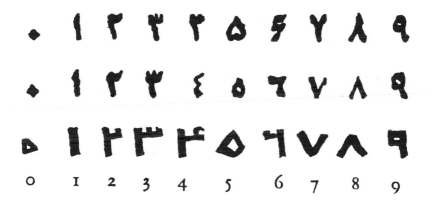

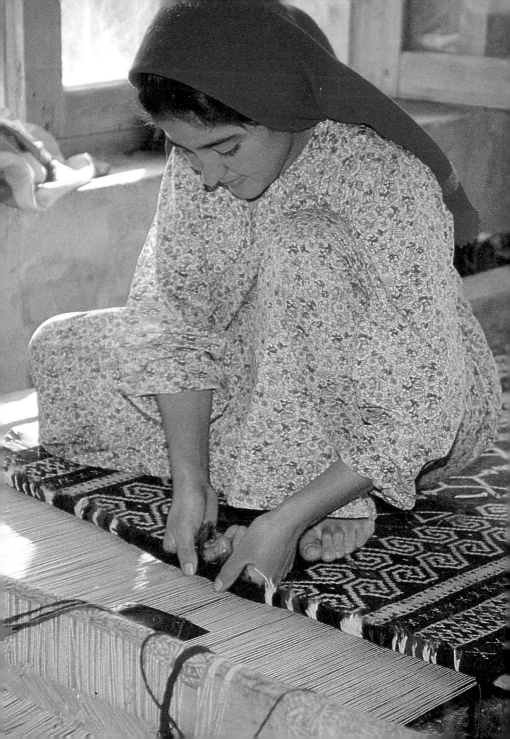

THE
IDENTIFICATION
PROCESS

THE PROCEDURE

E VIDENCE used in the identification and classification
of Oriental rugs is visual, structural and to a lesser degree
tactile (about 30, 60 and 10 per cent respectively).
You must proceed step by step:

Step one is the visage, or visual appearance of the rug's face as it
stares up at you from the floor.

Step two is the tactile message it gives you when you touch it
front and back; is it rough or smooth, hairy and bristly or
velvety and silky, and so on.

Step three is an examination of the tell-tale signs you will learn
to read on the back – the structure.

An exhibition of rare rugs and carpets took place in London a
few years ago. The organisers knew only that the rugs exhibited
were very valuable and put up huge DO NOT TOUCH signs.
When the *cognoscenti* arrived there was nearly a riot and the

*Opposite: A
Turkoman girl
weaving on a
loom, Iran.*

signs had to be hastily removed. If a rug or carpet is permanently on display, it will certainly suffer eventually from the acid in a thousand thumbs and forefingers, but some means must be provided for seeing at least part of the back as well as the front.

THE 'REAL THING'

The first skill, and one that is fairly readily acquired, is the ability to distinguish between genuine hand-made rugs and machine-made copies. An elementary test is to compare the back with the front. If you are looking at the genuine article, you'll find that the pattern on the back is virtually as clear as it is on the front; in mechanically produced rugs, the pattern on the back is considerably muddier, lacking in definition.

VISAGE

Hand-made Oriental rugs will be found after fairly cursory but observant examination, to display asymmetrical design features. There may be two stylised flower heads in one corner, for example, and only one in the other. Or there may be a repetitive motif which varies in scale, or the outlines of which, when studied in detail, vary from one to another. Often there are inconsistencies in colour or hue of colour (see Abrash, page 26) or designs that are incomplete at the borders, simply because the weaver ran out of space.

If, having studied the visage for a few minutes, you find no such variations; if every stem and flower on the right is perfectly echoed by an identical stem and flower on the left, and if each

zig-zag is perfectly compensated by another, and the whole is perfectly balanced in the central field, beware.

TEXTURE

If the texture is smooth, thin, glossy and soft and if the whole thing has the floppy consistency of a dish towel, once again, beware. Most hand-made Oriental rugs are made from yarn carded by hand and from wool processed amateurishly by a technically unskilled person, using unsophisticated methods. They are therefore lumpy, or even bristly. The wool is hard, frequently leathery to the touch. There are of course silks and other genuine rugs that will be smooth and glossy in feel, but the test suggested above, under 'Visage', should have ruled these out – if you have found visual irregularities, you already know that you may be looking at the genuine article.

STRUCTURE

If the first two tests have made you suspicious, you should now be able to confirm your suspicions by looking at the back. Warps and wefts running up and down, north to south and east to west with monotonous regularity, like little motorways, are almost certainly the result of mechanical production. These days you may even find the ultimate giveaway: a printed warranty on a fancy label, with the mysterious history of the art breathlessly told in spell-binding terms, a piece of potted poetry, and maybe even a red seal thrown in for good measure!

No genuine hand-made rug has such a label. At the most you might find something saying restrainedly 'Made in Afghanistan' or 'Product of Iran'. But in the majority of cases

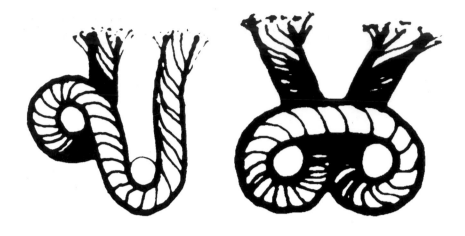

Above right:
Symmetrical
'Ghiordes'
Turkish knot.

Opposite: Side
section of
(above) the
Persian knot
and (below)
the Turkish
knot.

the real thing will preserve a dignified silence as to its true origin and identity.

How Rugs are Made

The critically important ability to recognise the 'handwriting' of the author on the back of an Oriental rug will come only with practice – it is like learning to read. In time you will find that your visual memory will develop like a sixth sense. In the meantime it is helpful to acquire an understanding of the structural elements that give different rugs their physical character – the weaver's alphabet of warp, weft and 'knot'.

First, the weaver sets up a loom on which is stretched a basic framework of vertical warps, north to south. A series of 'knots' is applied horizontally, row by row, to this framework.

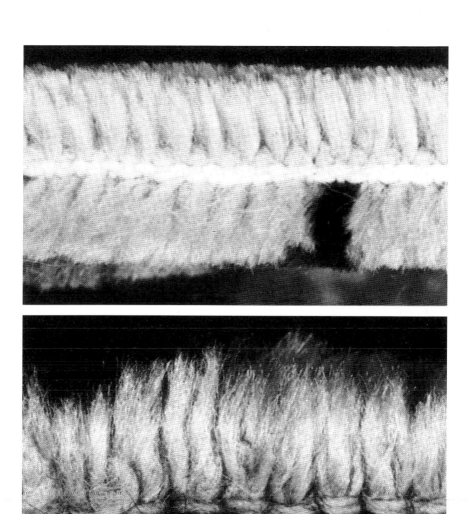

The knot is a loop of wool, inserted between, or applied to, two warps at a time. The loop is either asymmetrical (Persian) or symmetrical (Turkish) in configuration.

The Persian knot is also known as the Senneh (*sennay*) knot, named after a town in north-western Iran. Paradoxically though, the senneh rugs, in company with the bulk of Persian breeds, are made with the Turkish or Ghiordes (*geeordez*) knot.

Between the rows of knots are inserted wefts varying in thickness, number and colour. The resultant physical relationship between warps, wefts and knots as it appears on the back of the rug, varies significantly from type to type, and, remarkably, the variations are loyal to the geographic region from which each type emanates.

The distinctive appearance of each variation constitutes the weaver's 'handwriting', and the ability to read this is the ultimate key to identifying the origin of a piece.

Knot type
Being able to tell the difference between Turkish and Persian knots is another useful technique in identification: almost all Caucasians for instance are made with the Turkish knot, so that Turkish knotting would be an important clue in deciding a borderline case. Unfortunately, however, it is not an easy skill to master, and the finer and therefore potentially more important the piece, the more it will resist giving up the necessary information simply by virtue of the physical density resulting from the large number of knots in a small area.

Another paradox is that this criterion is established by examining not the back but the front of the rug. The pile has to

be prised open gently with the fingertips horizontally across the face of the rug to expose the roots of a row of knots. In the Turkish technique the warp shoots are both obscured by the loop of the knot, and revealed immediately above and below, whereas in the Persian technique only alternate warps are so obscured and revealed. Furthermore the asymmetry of the Persian knot tends to make both the clipped ends of a single knot loop point noticeably more sideways than the Turkish, whose ends tend to emerge head-on.

'Double knotting'

This technique is referred to in the trade as the Dhufti (*juftea*) knot. Double-knotting' sounds good but it is, in fact, inferior. It simply means that each knot is inserted around four warps instead of two and can therefore be done at approximately twice the speed. It follows, of course, that the end result is a much coarser and weaker structure.

Knot shape

Density, tension of application to the warps and the number and positioning of wefts will affect the appearance of the 'node', i.e. the bulb of the knot as seen from the back – some nodes are taller than they are wide, some more or less square, and so forth.

Wefts

The number of wefts between each row of knotting can vary from one to three, and vary erratically within the same rug, so that you can find two weft shoots followed by one, then three and so forth: the thickness of the actual weft filament can alter

from row to row, occasionally even within a row as it travels from left to right.

The colour of the wefts does not relate to the colours in the face of the rug, because the wefts are visible only on the back. *Below: Knots* Certain types usually have wefts of certain colours, clearly visible *and line of* on the back, regardless of what is going on in the front. By and *pile.* large, the more wefts the poorer the rug. Packing with weft shoots tends to thicken and solidify the structure, giving the rug a board-like feel which seems impressive but is not really so (except in the case of the Bidjar (*beejar*), see page 73). In Iran they judge a man's wealth by the thinness of the rugs on his floors.

Certain types almost always have the same colour of weft, for example Quasgai (*cashkye*), see page 101, usually has brownish wefts as an identifying feature.

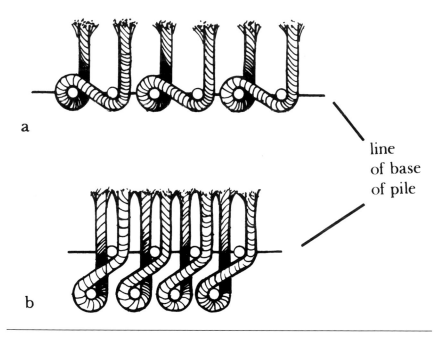

a

b

line
of base
of pile

Warps

Where the knotting is of an even, moderate tension, the warp lines as seen in cross-section from top to bottom would appear flat, even, and more or less in their original position. But this factor varies in degree, to the extent that the knot may be so tight as to pull each alternate warp virtually underneath its neighbour, resulting in a markedly 'ribbed' effect on the back, clearly visible to the naked eye.

Pile

On the face of a newly knotted rug are knot 'tails', all approximately but not exactly the same lengths. Different weavers and hence different rug types have different heights of pile. The newly knotted rug is cut across the visage by hand, and this is an important part of the skill. City pieces and certain tribal ones are close-cropped which helps to crystallise the pattern – the longer the pile, the less detail is exposed. Thus long piles are normally left only on rugs such as Caucasian, where the bold patterns are not reliant on detail for their overall impact.

MATERIALS

The materials used in the production of Oriental rugs and carpets vary tremendously from place to place and in themselves can contribute to the detective work of establishing their place of origin. Various combinations of materials are common, such as wool on wool, i.e. woollen loops inserted on a wool warp and weft base, wool on cotton, wool on jute, silk on silk etc.

WOOL

Previous pages:
The Kirghiz
tribe with their
livestock,
Afghanistan.

The wools employed vary greatly in themselves, mainly in relation to the breed, age and condition of the animals from which they have been clipped, and also the environment in which the animal lived. As a general rule sheep and yaks from high terrain will yield longer and thicker wool than lowland animals because of the way in which the animal's metabolism reacts to temperature.

Rugs are sometimes made from wool taken in a winter clip from the sheep's neck and this is naturally the oiliest wool. Rugs made with such wool, called kurk, have a noticeably more lustrous sheen, provided the dyemaster does his work with expertise and restraint. Occasionally the fleece of a dead animal is employed, imparting a predictably lacklustre appearance to the rug itself.

COTTON

Cotton is the next most common constituent, frequently providing the warp and weft framework into which the wool and, occasionally, silk loops are inserted. A cotton base of this sort can generally be considered inferior. 'Art silk', a trade adulteration meaning simply 'mercerised' cotton, which attempts to imitate silk (see Kayseri p.174), is very inferior.

SILK

Real silk, being an expensive material, is normally found only in pieces of high quality. In its natural colour it is frequently used to highlight pattern outlines in an otherwise woollen rug, for

example 'part silk' Qum (*koom*), Kashan, Ispahan, or on a cotton base, the pile consisting entirely of silk, or 'silk on silk' where the loops of silk are inserted in a framework of silken warps and wefts. Silk is most commonly found in city pieces, but can be found in some modern tribal productions, notably Turkoman.

There are two simple ways of testing whether silk is real or not. Firstly, if you lay the back of your hand on the visage, a silk piled rug will feel distinctly cool. In cases of serious doubt or dispute a fragment of warp may be removed and burnt. Silk burns differently from cotton. The latter burns longwise like a fuse, but the former flares and shrivels up.

Overleaf:
Boiling cocoons
to produce silk
in Ferghana
Valley,
Uzbekistan.

ANIMAL HAIR

Hair from goats or camels is used occasionally in the wool ply of poor quality, usually nomadic pieces, and imparts a noticeably bristly or spiky feel to the wool, not to be confused with the hard, flat, leathery texture of mid-western Persians like Ferraghan. The latter are short-cropped and the former medium length in pile. More commonly animal hair is employed in the securing side ropes or 'selvedges'.

'GOLD', 'SILVER', AND METAL THREAD OR WIRE

These materials are typically found in Turkish Hereke (*herraykay*) rugs: a silver or gold thread is wound round a silk core, and in some cases actual wire is used. The strength of such filaments relative to adjacent silk produces much tighter knotting and usually results in a marked area of declivity in the visage.

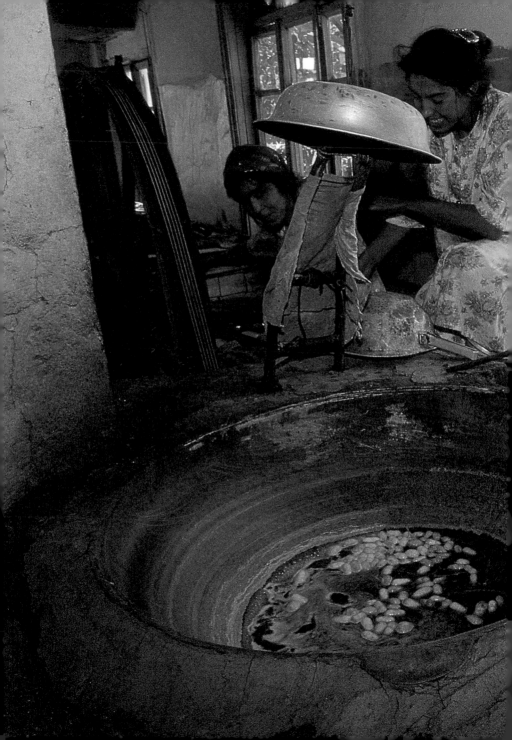

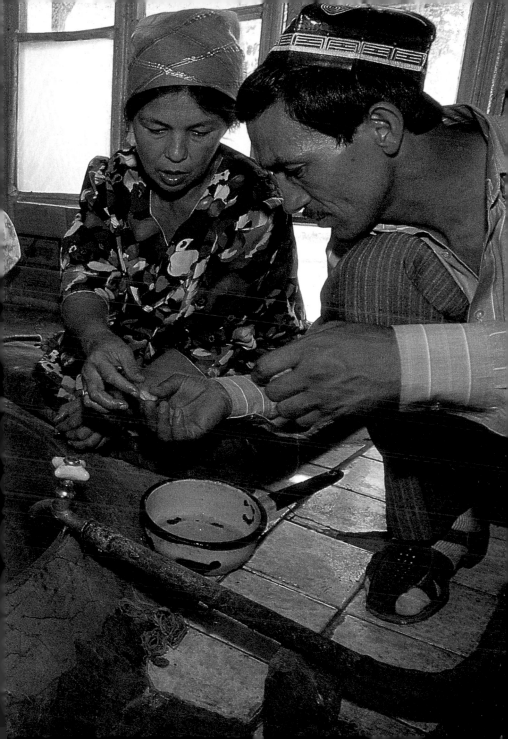

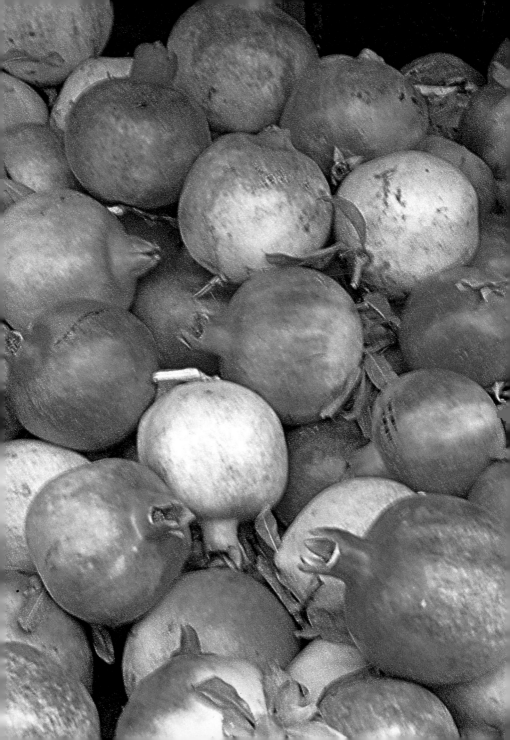

HEMP

Hemp and/or jute is visible mainly in modern Turkish commercial goods such as Kula (*koola*), where a glance at the back will reveal a distinctly 'sackcloth' structure of warp and weft, a hessian finish still occasionally detectable by smell.

DYES

Until the late nineteenth century, the wool in Oriental rugs was coloured with dyes made from natural sources; mostly plants and insects. Cochineal is obtained from the Dactylopius coccus insect found in cacti, but the bulk of the reds were derived from the root of wild madder, blue from the indigo plant, yellow from saffron, isperek (milkwort), vine leaves and pomegranate, and also from buckthorn. Green came from turmeric berries, blacks and greys from brazil or logwood, brown from nuts and tree bark. These materials, carefully blended according to closely guarded recipes handed down from generation to generation, produced colours the hues of which cannot to this day be chemically reproduced.

 In the late nineteenth century, Western commerce visited one of its occasional unintentional curses on the Third World. The weavers in Turkey and Persia were introduced to aniline dyes which they welcomed because they were cheap and saved all the painstaking hours formerly spent over the boiling vat. The passage of time, however, revealed the mixed nature of this blessing: the dyes were unstable and colours changed hue,

*Opposite:
Pomegranates
were once used
as a source of
yellow dye.
Cheap,
'labour-saving'
chemicals from
the West sadly
put paid to the
use of the
individual
and infinitely
superior
natural dyes.*

almost always for the worse. Certain dyes also physically attacked the wool, corroding the face of the rug and producing an intaglio effect, which in itself affected the hue because the light struck it differently.

These events, combined with structural short-cuts taken at the same time to increase output, resulted in a degeneration in quality of output so serious that edicts were issued by the Shah declaring that dye houses could be destroyed and that dyers found using the forbidden chemicals could have their right hand amputated.

By the 1920s of course the West had moved on and synthetic dye stuffs were produced which were, and continue to be, used widely in rug output without catastrophic results either for the rugs or the dyers.

Thus the bulk of production in the last fifty or sixty years boasts colours resulting from the use of a mixture of chemically based and natural dyes, and many very beautiful and desirable pieces are so coloured.

To the discriminating eye, however, some of the hues are visually aggressive, and there are now new initiatives, some government-sponsored, to reintroduce the use of dyes derived from natural sources only. This antipathy to chemical dyes should not be dismissed as precious self-indulgence on the part of the connoisseur because the use of chemicals does have two serious disadvantages:

The first disadvantage is stability. The very fact that the artificial dyes are now so admirably stable takes away an integral part of the traditional charm of an ageing rug. The hues do not mellow to produce the subtle patina of age as did the natural dyes. Secondly, there is universality. The synthetic dye comes

out of the can in Kurdistan exactly the same hue as it does in Herat, thus denying an important source of information: in older pieces, the hue of the colours is a tangible aid to indentification. In eastern Persia, for instance, the most common base of the red was cochineal and in the West, madder. Thus the blue-red of the former, compared to the rust red of the latter, could be a helpful clue in identification. Thus does 'progress' blur character and individuality.

THE SIGNIFICANCE OF COLOUR

Many colours used in the rugs are understood to have a meaning often intriguingly at variance with their significance (if any) in the West.

WHITE – is the colour of mourning.

RED – burns with passion. It is the colour of vibrant life, happiness and success, especially in creative activities.

YELLOW – the colour of the sun, indicates plenty, riches and glorious power.

GREEN – as elsewhere, signifies renewal and growth, but, more importantly for Muslims, holiness, as it was the colour of Mohammed's coat, and therefore not suitable to be walked upon and not used by them in rugs for that reason.

BROWN – indicates fruitful fertility.

ORANGE – sometimes interpreted in the West as the colour of hatred, is, in reverse, the colour associated with sympathetic feelings like devotion and tenderness in the East.

Right:
Flowerheads,
naturalistic
(above) and
stylised (below).

CLASSIFICATION –
THE GREAT DICHOTOMY

There are two distinct families or types of rugs. They are rarely, if ever, to be confused with each other and you will soon learn to distinguish them at a glance. They are: city pieces and tribal or village pieces. Here at least, is one concrete, virtually incontrovertible rule.

The first criterion that divides all city pieces from all tribal (village) pieces is the visage. All city pieces are curvilinear in pattern, i.e. they are characterised by rounded, circular elements, scrolls, arabesques, flowers that look like flowers, birds and trees. These patterns are usually densely and intricately interwoven. They are 'formal' in appearance.

By sharp contrast, all tribal (village) pieces are visually geometrical, incorporating diamonds and squares, or other elements outlined with straight edges, for example flower heads which are 'stylised' (*see opposite*).

The most important starting point in categorisation is therefore always: City or Tribal. If it's city – which city? If it's tribal – which broad geographical area of origin? It may be from north-west Iran (Kurdish etc.); central western Iran (Hamadan and all its cousins); south-western Iran (Quasgai, Shiraz, Afshar); nomadic (Belouch), Afghan, Turkoman (Bokhara and its brothers and sisters) and Caucasian, Turkish and 'the rest'. Once this stage of learning is achieved, you can then move on to establish the actual city or tribe and other details.

CITY PIECES

THE majority of important 'city' pieces come from half a dozen famous cities in Iran. They are, broadly speaking, situated on a spine running from Tabriz in the north-west, via Ispahan, Kashan, Nain (*naa-een*) and Qum (*koom*) to Kerman in the south-east.

You will find that they are most commonly *zaronyms* or *dozars* (see Chapter 1), approximately 5 x 3 feet or 7 x 5 feet respectively. Silks, or part silks, are found more frequently among these breeds than others.

They are made in the cities from which they take their names, in 'manufactories'. These are organised places with a foreman and weavers who work from loom patterns and cartouches of designs. While no two are ever (or rarely) the same, they share a classical or established style or pattern that has been handed down over the centuries. (An exception is Qum, where rugs were not made at all until the 1920s. Qum pieces have built up from classical elements a character and personality which is quite distinctive, yet modern in the sense that it originated and was developed in the twentieth century.)

Leaving rare or antique pieces aside, the best in technical quality are Kashan, Ispahan, Nain, Qum and the Turkish silk Hereke, but not necessarily in that order. They will rarely, if ever, descend below a knot count of 200 per square inch, and may not all that uncommonly reach as high as 500. They command prices of £1500 ($2500) upwards (zaronyms) and £3000 ($5000) upwards (dozars). Excluded from this category

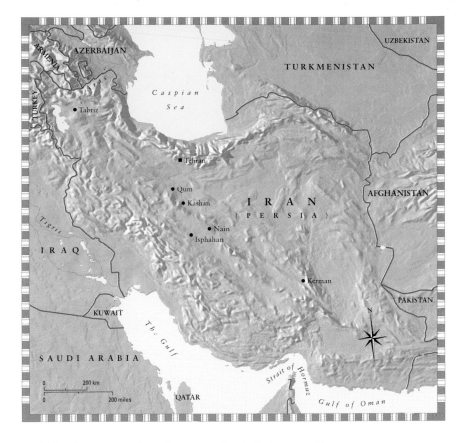

would be the poorest pieces in terms of technical quality from
Kerman, and wool Hereke, which, unfortunately, in the modern
production, can be very poor indeed. With knot counts as low as
100 per inch or less, they are thick pieces, whose coarse structure
results in a muddy, ill-defined visage. One observer has described
them as 'polychromatic floor coverings' and they are frequently
what we would call 'commercial' goods. You should be able to buy
goods of this sort for around £300–450 ($500–750) (zaronym)
and £500–750 ($800–1250) (dozar).

TABRIZ (Persian)

VISAGE: MODERN
PRODUCTION, POOR IN
QUALITY. DOWDY, OFTEN
FLORAL AND WITH TREES,
PALMETTES, CENTRAL
MEDALLIONS. PATTERN
POORLY DEFINED, BLURRED
BECAUSE OF THE COARSENESS
OF THE KNOTS.
UNDISTINGUISHED, LACKING
CHARACTER AND AUTHORITY. BY CONTRAST SOME OLDER EXAMPLES
(1920S AND EARLIER) ARE EXCELLENT.

COLOUR/HUES: PALE BLUES, SOME INDIGO FOR DEFINITION, SOFT ROSE
TO MID-ROSE, OFF-WHITES AND OCCASIONALLY YELLOW, EVEN SOFT
GREEN IN DETAILS.

TEXTURE: SOFT, WOOLLY, THICK, MEDIUM PILE.

STRUCTURE: NODES LUMPY; WEFTS IRREGULAR IN THINNESS, NOT
STRAIGHT, APPEARING AND DISAPPEARING ERRATICALLY. KNOT COUNT
AS LOW AS 100 PER SQUARE INCH, OR LESS; RARELY MORE THAN 200
(MODERN PIECES). KNOT TYPE IS TURKISH (GHIORDES).

SIZE: 5 X 3 FEET UPWARDS; SOME QUITE BIG PIECES AVAILABLE (E.G. 15 X
12 FEET).

PRICE: £30-130 ($45-195) PER SQUARE FOOT.

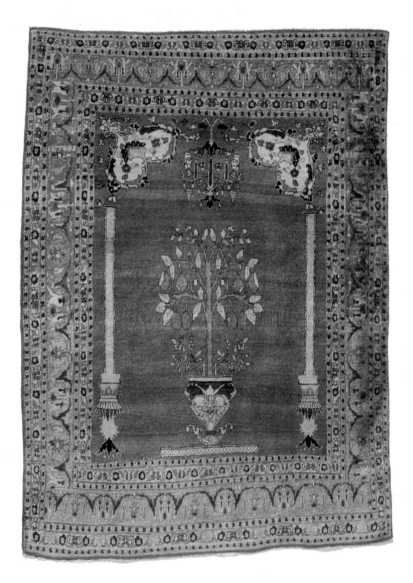

Above: Tabriz prayer rug with Tree of Life motif in the centre field.

Opposite: Detail of back of a Tabriz. Note the broken, erratic appearance of the wefts.

ISPAHAN (Persian)

To many observers, the Ispahan as a breed are at the summit of the art. Right up to modern times they have maintained an outstanding standard of excellence, and the twentieth century produced a 'master' weaver – one Serafian, whose rugs are signed, usually in a small panel (see Signatures, Chapter 1). They are never cheap, so if anyone offers you a cheap 'Ispahan', beware.

VISAGE: CRISP AND CLEAN: GIVES OFF AN AURA OF CALM, SPACIOUS AUTHORITY. VERY BALANCED AND SYMMETRICAL. A CENTRAL MEDALLION SURROUNDED BY A RELATIVELY UNCLUTTERED OPEN FIELD, ATTENDED BY CRISP USE OF EXTENDED WHORLS (VINES) AND PALMETTES, TYPIFIES THE BREED. THE CLARITY OF DEFINITION IN DETAIL IS THANKS TO THE INVARIABLY FINE KNOTTING.

COLOUR/HUES: CLASSICALLY, AN IVORY FIELD WITH PALE BLUES, SOFT ROSE AND INDIGO OR MADDER FOR THE HERATI MOTIF. HUES MOSTLY COOL AND SOFT, GIVING A QUIET, PEACEFUL EFFECT.

TEXTURE: SMOOTH, CLOSE-CROPPED, DENSE VELVETY PILE

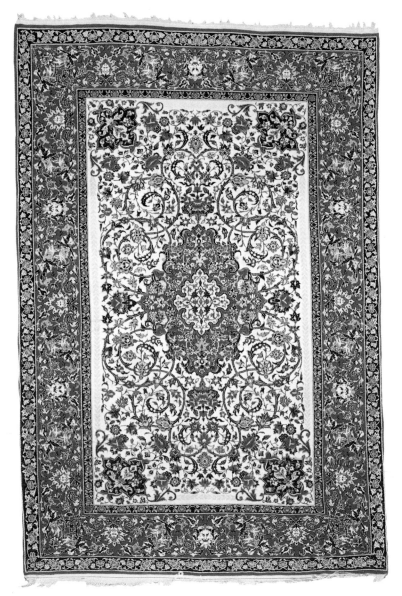

*Left: Ispahan.
Note the
spacious open
effect.*

*Opposite:
Detail of back
of an Ispahan.
'Blips' in
appearance of
wefts.
(c.f. Nain)*

STRUCTURE: EXTREMELY FINE; TINY TIGHT NODES SEPARATED BY WEFTS WHICH APPEAR AND DISAPPEAR, GIVING A DOT-DASH-DASH-DOT APPEARANCE, DISTINGUISHING THE TYPE FROM ITS CLOSE SISTER, THE NAIN. MADE FROM THE FINEST WOOLS, FREQUENTLY PART SILK OR ALL SILK. PERSIAN KNOT COUNTS RARELY BELOW 300 PER SQUARE INCH AND HIGHER IN SILKS AND OLDER PIECES.

SIZE: COMMONLY ZARONYM AND DOZAR; THE LARGER PIECES ARE WELL WORTH SEEKING OUT.

PRICE: ZARONYM £3000 ($4500) UPWARDS; DOZAR £5000 ($7500) UPWARDS. LARGER PIECES CAN COST VERY SUBSTANTIAL SUMS E.G. £30-50,000 ($45-75,000) DEPENDING ON AGE AND CONDITION.

NAIN (Persian)

A close cousin geographically to the Ispahan, and in quality often to be distinguished in only structure.

VISAGE: DENSE. SCROLLS AND ARABESQUES PROLIFERATE WITH CENTRAL MEDALLIONS AGAIN COMMON. A CURIOUSLY BLAND OVERALL APPEARANCE IS CHARACTERISTIC. SOME WOULD SAY THEY LACK 'DEPTH', VISUALLY.

COLOUR/HUES: MOST COMMONLY COOL BLUES PREDOMINATE WITH OFF-WHITE FOR DEFINITION.

TEXTURE: SOFT, CLOSE-CROPPED.

STRUCTURE: TIGHT, VERY REGULAR, HONEYCOMB, ALMOST 'RIBBED' EFFECT. MATERIAL OFTEN PART SILK BUT WOOL READILY AVAILABLE. PERSIAN KNOT COUNT UNLIKELY TO BE LESS THAN 300 OR MORE THAN 500 PER SQUARE INCH.

SIZE: RARELY LARGER THAN 12 X 9 FEET.

PRICE: ZARONYM £2000 ($3000) UPWARDS; DOZAR £4000 ($6000) UPWARDS.

Right: Detail of back of a Nain. Much more disciplined than the Ispahan.

Opposite: Nain visage, densely filled.

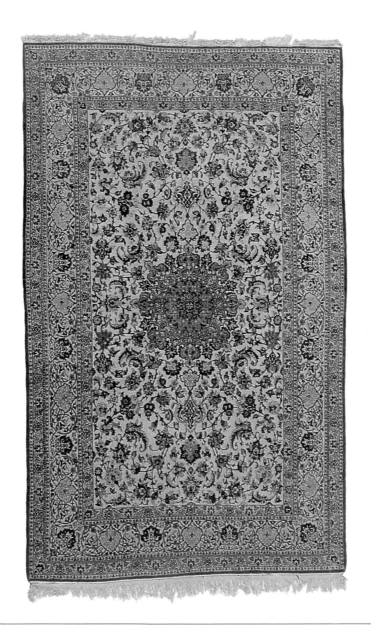

KASHAN (Persian)

This is one of the names with which most people are familiar, perhaps because they were frequently brought home by returning British soldiers in the early part of the twentieth century.

VISAGE: DENSE, FREQUENTLY WITH FORMAL BALANCE OF CENTRAL MEDALLION, AND SPANDRELS TO THE CORNERS.

COLOUR/HUES: CLASSICALLY THEY ARE DARK REDS AND BLUES, OFTEN WITH LITTLE RELIEF, GIVING A VERY RICH, IF SOMEWHAT GLOOMY APPEARANCE. THERE IS ALSO A MODERN TYPE AVAILABLE, DESCRIBED AS 'BLONDE' OR 'WHITE' KASHAN. IN THERE THE FIELD IS IVORY OR OFF-WHITE AND THE OTHER COLOURS ARE PALE BLUE AND A MID-GREEN.

TEXTURE: CLOSE-CROPPED, PERHAPS MORE 'WIRY' THAN OTHER CITY PIECES.

STRUCTURE: COMMONLY DISPLAYS THIN, PALE BLUE WEFTS WITH ALTERNATE WARPS MARKEDLY DEPRESSED. MEDIUM TO FINE, MOSTLY WOOL, PERSIAN KNOT COUNT 200-300 PER SQUARE INCH.

SIZE: MOST COMMONLY DOZAR, 7 X 5 FEET; SOME 'BLONDE' (OR 'WHITE' SEE ABOVE) KASHAN ARE TYPICALLY BIGGER — 12 X 9 FEET.

PRICE: £3,000 ($4500) UPWARDS FOR DOZAR; BLONDE KASHAN £8-9000 ($12,000-13,500) UPWARDS.

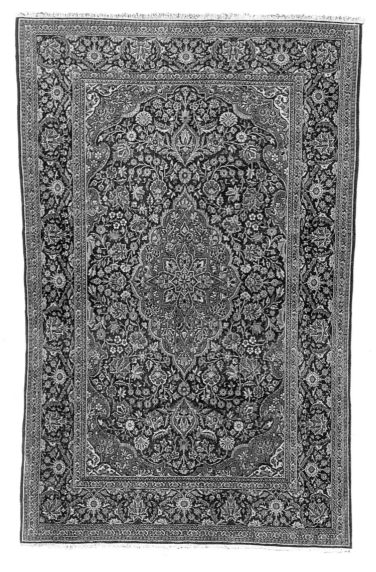

Left: Kashan.

*Opposite:
Detail of back
of Kashan.
Note the
wobbly blue
wefts.*

QUM (Persian)

Opposite:
Qum.

Right: Detail
of back of
Qum.

The first Qum were not produced until the 1920s, so if anyone offers you an 'antique' Qum, make your excuses and leave! The rugs have already established themselves as a distinctive breed, of high quality. During the 1980s or so they were greatly in vogue as the ultimate luxury in glossy, glamorous silk; contemporary taste has turned away from them to a certain extent, however, in favour of more ethnic pieces.

VISAGE: TYPICALLY AN INTRICATE PORTRAYAL OF BIRDS, DEER, TREES, FLOWERS, BUT CAN BE FOUND WITH MORE OPEN FIELDS, PARTICULARLY IN PRAYER RUG FORMAT WHERE LARGE FIELDS OF 'SELF' COLOURS LET THE GLOWING SILK SPEAK FOR ITSELF.

COLOUR/HUES: USUALLY SOFT AND APPEALING; OLD ROSE, PALE BLUES AND SO ON, BUT OCCASIONALLY HARD AND LURIDLY EASTERN.

TEXTURE: FREQUENTLY THE SOFTEST SILK, OR PART SILK AND WOOL.

STRUCTURE: ALL-WOOL PIECES ARE MEDIUM PILE. WEFTS SHOW IRREGULARLY IN DOT-DASH STYLE. FINE TO VERY FINE, 300-500 PERSIAN KNOTS PER SQUARE INCH, AND MORE IN SILK.

SIZE/PRICE: ZARONYM, 5 X 3 FEET, £1500 ($2250) UPWARDS; DOZAR, 7 X 5 FEET, £3000 ($4500) UPWARDS.

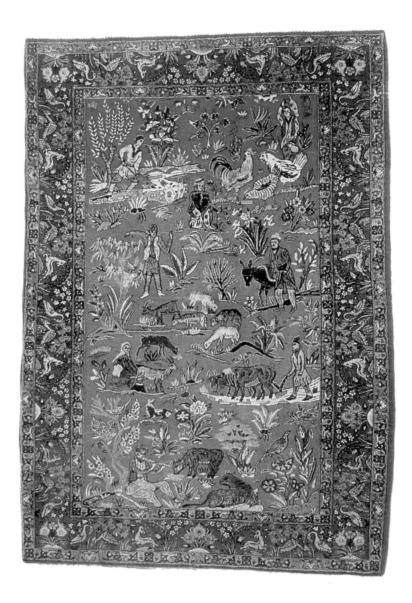

Above: A Kerman runner.

KERMAN (Persian)

Older pieces were excellent, often known as 'Laver' Kermans from a rug-weaving centre just to the north of the city; modern pieces are mostly crude, thick, poorly executed and much corrupted by attempts to meet Western taste.

VISAGE: IN THEIR COMMON, MODERN FORM, LARGE PLAIN FIELDS WITH FORMAL CENTRAL MEDALLION, GARLANDS AND BOUQUETS WHICH ARE VERY POPULAR IN THE AMERICAN MARKET.

COLOUR/HUES: STRONG AND TOTALLY UNSUBTLE PLAIN FIELDS IN INDIGO, MADDER, EVEN GREEN.

TEXTURE: UNSYMPATHETIC, OFTEN BRISTLY WOOL. MEDIUM TO THICK PILE.

STRUCTURE: LUMPY NODES, COARSE YARN; PERSIAN KNOT COUNTS 100 PER SQUARE INCH.

SIZE: A FULL RANGE OF SIZES IS AVAILABLE, INCLUDING RUNNERS.

PRICE: 7 X 5 FEET AROUND £900-1200 ($1350-1800).

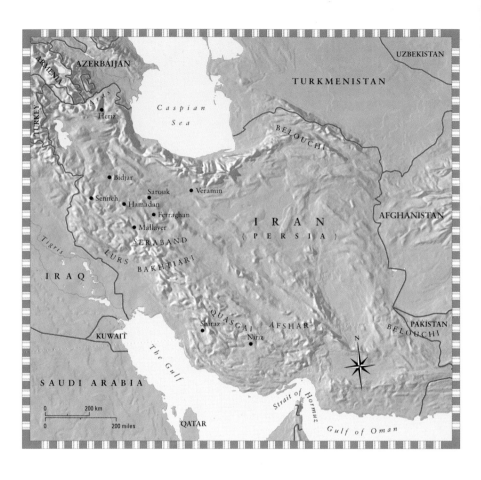

ARMENIA

AZERBAIJAN

UZBEKISTAN

TURKMENISTAN

Caspian Sea

Aras

TURKEY

Heriz

BELOUCHI

Bidjar

Sarouk Veramin

Senneh Hamadan

Ferraghan

AFGHANISTAN

Mallayer

I R A N

Tigris

SERABAND

(P E R S I A)

LURS

BAKHTIARI

I R A Q

QUASGAI

AFSHAR

PAKISTAN

Shiraz

BELOUCHI

KUWAIT

Niriz

N

The Gulf

SAUDI ARABIA

0 200 km

0 200 miles

QATAR

Strait of Hormuz

Gulf of Oman

TRIBAL AND VILLAGE FAMILIES ~ IRAN

TRIBAL AND VILLAGE OUTPUT

THE common practice in the trade is to refer to all non-city pieces as 'tribal' or 'village'. They range from nomadic, honestly humble peasant products which are rough, even crude but almost always characterful and pleasing, to the genuinely rare (Caucasians mostly) and Turkoman. The Caucasians are much sought after for their stunning 'simplicity' and vivid palette, while the Turkoman are highly regarded because they are often outstanding examples of craftsmanship with remarkably high knot counts.

This bewildering array is tackled below geographically, although the resulting groupings are not necessarily categories: geography creates the odd strange bedfellow.

NORTH-WEST IRAN

Our geographical tour begins here in the province of Kurdistan, home of the fiercely independent Kurdish tribesmen. Their work is often self-expressively primitive, savage in simplicity and

*Right: The
'iron man' of
Oriental Rugs,
the Bidjar. A
beautiful
example, crisp
and dramatic.*

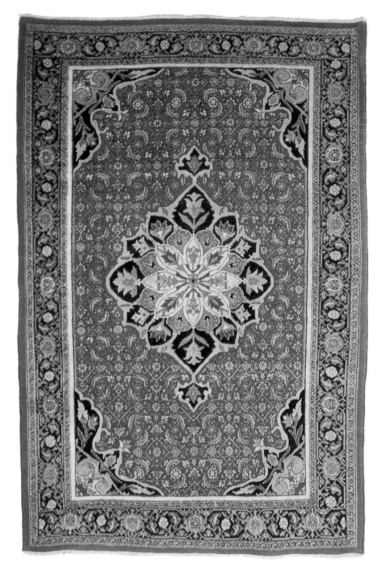

colour, with strong reds and frequently an extensive use of orange. Many Kurdish rugs manifest a kinship with the products of the Caucasian region, across the border, which will be dealt with later.

The two most important rug names from Kurdistan are Bidjar and Senneh, which are neighbours only geographically.

BIDJAR (Persian)

The Bidjar is known as the 'iron man' of Oriental rugs; when new it is almost impossible to bend or fold, so compact and stiff is the knotting and the heavy packing of the wefts.

VISAGE: SOMBRE, TENDING TO A REPETITIVE OR 'OVER ALL' PATTERN; COMMONLY FLORAL, RATHER STYLISED, FREQUENTLY 'HERATI'. ALTHOUGH WE CLASSIFY IT AS A TRIBAL PIECE, THIS IS ONE WHICH MIGHT GIVE YOU TROUBLE. (TO THE UNTRAINED EYE IT LIES BETWEEN 'GEOMETRIC' AND 'CURVILINEAR' BUT WITH A LITTLE EXPERIENCE YOU WILL FIND THE STRUCTURE UNMISTAKEABLE.)

COLOUR/HUES: COMMON USE OF DULL INDIGO, MADDER RED, OCCASIONALLY WHITE, CHERRY RED AND PALE BLUE TO THE DETAIL.

TEXTURE: HEAVY, STIFF, BOARD-LIKE THICKNESS, SOMETIMES NOT MUCH LESS THAN AN INCH THICK. WOOL, MEDIUM-COARSE, LONG PILE, A LITTLE UNFRIENDLY TO THE TOUCH.

Above: Detail of a more floral example of a 19th century Bidjar.

Opposite: Detail from the back of a Senneh.

STRUCTURE: TURKISH KNOT 100-200 PER SQUARE INCH. THE WARPS ARE FREQUENTLY SO TIGHTLY KNOTTED AS TO LIE ONE UNDER THE OTHER, WHICH IS WHY THE CARPET IS SO STIFF.

SIZE: 9 X 6 FEET AND BIGGER.

PRICE: £4500 ($6750) UPWARDS; THE BEST BUY FOR VIRTUAL INDESTRUCTIBILITY.

SENNEH (Persian)

The Senneh is well known for two reasons: it has given its name to the Persian or asymmetrical knot (with which, incidentally, the Senneh itself is not made) and it is a type much admired by the aficionado.

VISAGE: THE MAIN
CHARACTERISTIC,
WHICH IT MAY TAKE
A WHILE FOR THE
EYE TO DECIPHER, IS
A 'PEPPER-AND-
SALT' APPEARANCE,
ESPECIALLY IN THE
BORDERS AND ALSO
ON THE BACK. AS
TO PATTERN,
DENSELY DETAILED;
EXTENSIVE USE OF
BOTEH IS
CHARACTERISTIC
BUT NOT
INVARIABLE.

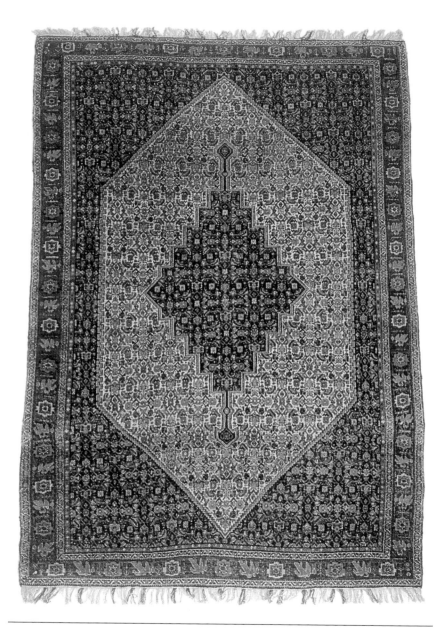

ORIENTAL RUGS

COLOUR/HUES: DARK TO MID-BLUES OR OLD ROSE; BROWNS AND FAWNS WITH LOTS OF IVORY.

TEXTURE: VERY HARD, LEATHERY; CLOSE-CROPPED TO THE DEGREE OF FEELING AS THOUGH THERE WERE NO PILE AT ALL. FEELS LIKE SANDPAPER ON THE BACK. 'SPIKY' WOOL; THE 'PEPPER AND SALT' VISAGE ARISES PARTLY FROM THE UNIQUELY GRANULAR STRUCTURE. VERY COMPACT AND HARD-WEARING.

STRUCTURE: KNOT COUNT (MODERN PIECES) ABOUT 150 PER SQUARE INCH; OLDER ARE FINER, TURKISH KNOTS.

SIZE: RARELY BIGGER THAN 7 X 5 FEET.

PRICE: £6000 ($9,000) UPWARDS DEPENDING ON AGE AND CONDITION.

Note *There are some thick modern 'Senneh' to which most of the foregoing would not apply: they would be classed as 'commercial' goods, albeit of good quality relative to other members of that category.*

Opposite: An example of a Senneh.

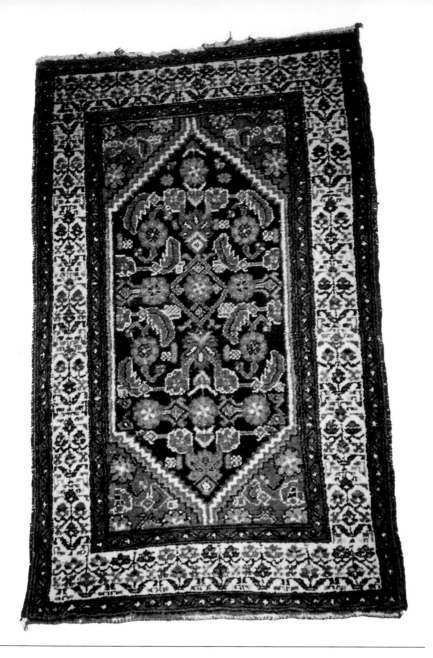

CENTRAL WESTERN IRAN

Moving south, our next port of call must be the city of Hamadan, 6000 feet up in the Zagros mountains, and the oldest royal town in Iran, founded by King Deioces in 700 BC. The royal palace was an interesting building, consisting of seven fortresses superimposed on top of each other, and coloured white, black, purple, blue, orange, silver and gold. The King occupied the highest for security and comfort, and ceilings and doors were 'sculpted' with layers of gold and silver.

Opposite: A typical Hamadan. The chintz of Oriental rugs.

HAMADAN (Persian)

Although the term 'Hamadan' is probably applied to more rugs than any other type, no rugs were produced there until quite recently. Their massive plurality is the result of the heavy output of some seven hundred surrounding villages, Hamadan being the commercial hub.

Hamadan, although they can (and should) be subdivided into sub-classifications, do represent a more or less homogeneous family of rugs, especially as to structure. The back of a Hamadan will always reveal one of two basic structural patterns. This is the 'handwriting' of the weaver.

In the first, a (frequently) thick single weft creates a dash-dash-dash-dot-dot pattern as it passes under and over alternate warps, and splashes noticeably on to and into the overcasting on the selvedge. Successive wefts passing under (where their predecessors passed over) the warp, extend the dot-dot appearance vertically. The dots vary in size, but once your eye has learned to find them out, you will never fail to identify a Hamadan.

In the second, an equally common Hamadan structural 'handwriting' is that described by one observer as 'quincunx', i.e. having the appearance of the '5' face as it appears on dice.

VISAGE: SOFT, BLITHE. FREQUENTLY FLORAL, BUT INFORMALLY SO, THE 'CHINTZ' OF ORIENTAL RUGS. STYLISED FLOWER HEADS ON STRAIGHT STEMS OR SIMPLE DIAMOND FIELDS WITH HERATI MOTIFS OR OVERALL PATTERN, SOME BOTEH.

COLOUR/HUES: SOFT PINKS, OLD ROSE, PALE BLUES, IVORY, DARK BLUE USUALLY ONLY TO DETAIL; OCCASIONALLY, AND SURPRISINGLY, SOME GREENS.

TEXTURE: MOSTLY WOOLLY, SOFT MEDIUM PILE.

STRUCTURE: ALL WOOL ON WOOL OR COTTON BASE. COARSE, OPEN WEAVE, NEVER FINE. MOSTLY TURKISH KNOT COUNT 50-100 PER SQUARE INCH.

SIZE: MOSTLY RUGS OF 5 X 3 FEET; SOME CARPETS AND HUGE PRODUCTION OF RUNNERS.

PRICE: SHOULD BE MODEST; ALLOW A MAXIMUM OF £15 ($25) PER SQUARE FOOT, DEPENDING ON AGE AND CONDITION.

Note *An important member of the Hamadan family is the Bordchalou, similar in every respect except for being notably thicker, longer and denser in pile. They will usually fetch more money, say £20 ($30) per square foot.*

MASLAGAN (Persian)

The Maslagan (known by some as Nobaran) is again clearly a member of the family except for the visage. They seem to have settled into this somewhat stereotyped, but crisply defined pattern, displaying a large body of a single colour, typically a strong red or midnight blue. These are usually more compactly knotted, closer cropped and more leathery in texture (in older pieces). Around £400–600 ($650–1000) for a 6 x 4 feet (modern).

Opposite: Detail from the back of a Hamadan showing the 'quincunx' pattern.

Right:
Maslagan.
Note the
invariable
'forked
lightning'
outline to the
central field.

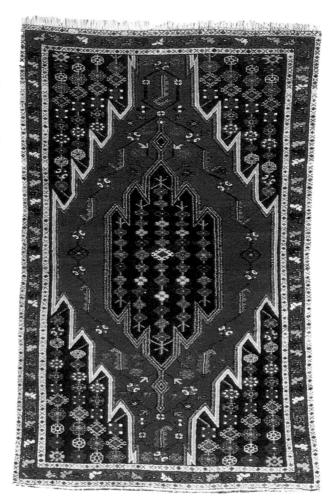

MALLAYER (Persian)

This is another notable member of the Hamadan family, and one indeed worthy of some considerable respect.

VISAGE: SOMBRE, EVEN 'FLAT' IN APPEARANCE;
CHARACTERISTICALLY, SQUARED-OFF ELEMENTS, AND (IN
MY EXPERIENCE) INFALLIBLY DECORATED AROUND THE
EDGE WITH A UNIQUE TREATMENT GIVING THE
IMPRESSION OF A STRING OF FAIRY LIGHTS.

COLOUR/HUES: DARK NAVY, STRONG RUSTY REDS, SOME
GREENS WITH WHITE AND POSSIBLY YELLOW TO THE DETAIL.

TEXTURE: STIFF, WIRY.

STRUCTURE: WOOL, COMPACT WEAVE, RARELY LESS
THAN 100 TURKISH KNOTS PER SQUARE INCH.

SIZE: MAY BE FOUND OCCASIONALLY IN SQUARE OR
NEARLY SQUARE SHAPES. RARELY REACH CARPET SIZE.

PRICE: FOR A 6 X 4 FOOT IN GOOD CONDITION (E.G.
1920S VINTAGE) £750-1000 ($1125-1500) UPWARDS.

CENTRAL IRAN

At this point we must make a small detour from our generally
southerly progress to visit the region of Arak, formerly
Sultanabad, home of Mahal, a little to the east, in order to
include two important tribal pieces, Ferraghan and Sarouk, and
two less important, Serabend and, a somewhat isolated source
to the east, Veramin. The former two are among the best of tribal
rugs from a technical standpoint. Thanks to their compact, leathery
weave, many fine old pieces are still around today. The latter
two are now 'commercial' goods of no particular significance.

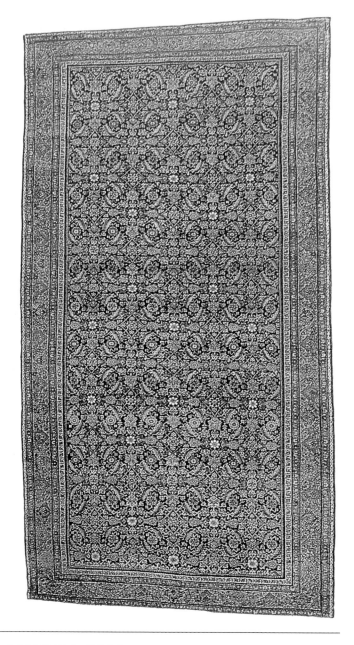

Right: An example of a Ferraghan overall Herati design.

Opposite: Detail from the back of a Ferraghan.

FERRAGHAN (Persian)

VISAGE: DUSKY. GENERALLY SOOTHING, PEACEFUL IN APPEARANCE THANKS TO THE EXTENSIVE AND RHYTHMIC USE OF THE HERATI MOTIF.

COLOUR/HUES: INDIGO, ROSE/BRICK REDS. BORDERS FREQUENTLY MANIFEST CELADON GREEN, MADE FROM COPPER VITRIOL WHICH CORRODES THE WOOL AND RESULTS IN A SCULPTED FEEL IF YOU CARESS THE BORDER AREA; FREQUENTLY THE CORROSION IS QUITE VISIBLE.

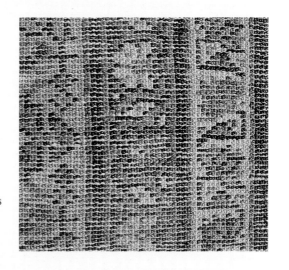

TEXTURE: STIFF, LEATHERY, THIN, GRANULAR.

STRUCTURE: WOOL, VERY COMPACT, CLOSELY CROPPED. THE BACK REVEALS A MARKEDLY 'RIPPLED' EFFECT RESULTING FROM A REGULARLY REPEATED, HIGHLY VISIBLE, CONTINUOUS, SINGLE WAVY WEFT LINE. TURKISH KNOT COUNT 150 PER SQUARE INCH AND BETTER.

SIZE: BIG PIECES AND RUNNERS ARE COMMON; ALSO KELEY (SEE CHAPTER 1).

PRICE: DOZAR £3000 ($4500) AND UPWARDS DEPENDING ON AGE, CONDITION AND KNOT COUNT.

Right: A magnificent example of a Sarouk/ Ferraghan from the 19th Century.

Opposite: Details from the backs of two Sarouks, (left) old, (right) modern, showing quite dramatically the finer knotting of the old but also the kinship of structure.

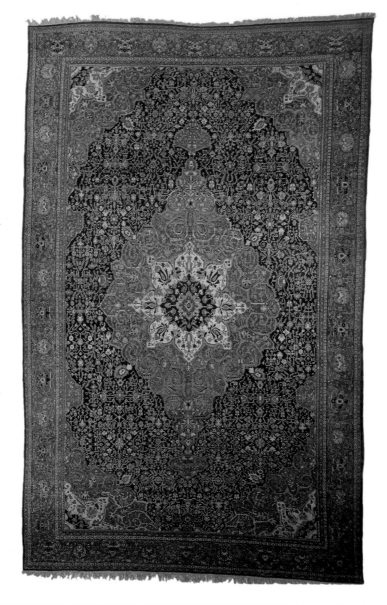

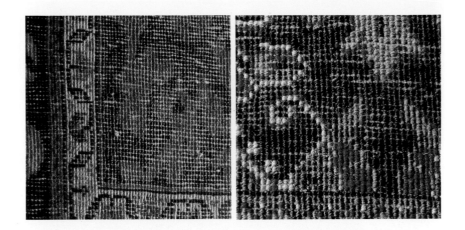

SAROUK (Persian)

VISAGE: BRIGHT, DENSE, CHEERFUL, CRISP, STYLISED FLOWER HEADS, CENTRAL MEDALLION NOT UNCOMMON; A LOT GOING ON. FREQUENTLY CLOSE AFFINITY VISUALLY TO MALLAYER, EVEN INCLUDING TRACES OF THE 'FAIRY LIGHT' GARLANDS.

TEXTURE: FLAT, HARD (SOME EXAMPLES OF MUCH LESSER QUALITY EXIST IN A THICK, COARSE VARIETY OF NO PARTICULAR INTEREST OR WORTH).

STRUCTURE: VERY TIGHT, COMPACT; KNOT COUNTS OF 150/250 (PERSIAN) PER SQUARE INCH. USUALLY SINGLE BRIGHT BLUE CONTINUOUS WEFT.

SIZE: THE BEST OF THESE PIECES, WHICH CAN BE CARPET SIZE, ARE HIGHLY PRIZED AT THE MOMENT AND THIS IS REFLECTED IN THE PRICES.

PRICE: AT LEAST £3-4000 ($4500-6000) FOR 6 x 4 FEET IN GOOD CONDITION.

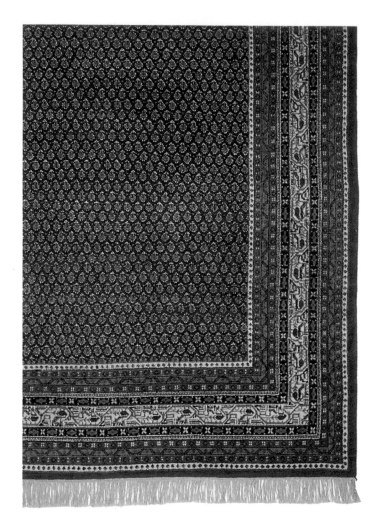

Right: Detail from a Serabend.

Opposite: Detail from the cartouche followed in weaving.

SERABAND/SERABEND (Persian)

VISAGE: QUIET, PEACEFUL, GENTLE/BORING. ALMOST ALWAYS WITH THE TEARDROP OR BOTEH PATTERN OVERALL, REFERRED TO IRREVERENTLY BY SOME AS THE 'FLEA' PATTERN.

COLOUR/HUES: MID-TO DARK BLUES, IVORY, BRICK RED.

TEXTURE: WOOL, FREQUENTLY FLUFFY (MODERN).

STRUCTURE: 50-100 TURKISH KNOTS PER SQUARE INCH (COARSE MODERN EXAMPLES, QUITE COMMON).

SIZE: SOME RUNNERS AMONG THE MODERN PIECES.

PRICE: NOT USUALLY TOO EXPENSIVE, SAY £450 ($675) UPWARDS FOR 6 X 4 FEET.

VERAMIN (Persian)

VISAGE: INVARIABLY USES A STYLISED FLORAL PATTERN KNOWN AS MINA KHANI AND IS THUS UNMISTAKABLE.

COLOUR/HUES: STRONG BLUE GROUND, CREAM AND ROSE-RED FLOWERS.

TEXTURE: SOMEWHAT THINNER AND FINER, MORE CLOSE-CROPPED THAN SERABEND OF WHICH THEY ARE OTHERWISE REMINISCENT.

STRUCTURE: 100 UPWARDS TURKISH KNOTS PER SQUARE INCH.

SIZE: MOSTLY 7 X 5 UP TO 12 X 9 FEET.

PRICE: 7 X 5 FEET, £1000-1500 ($1500-2250).

BACHTIARI (Persian)

Continuing in a southerly direction, we now meet a colourful and important tribe, the Bachtiari. The tribe are bi-annually nomadic, migrating with their herds from the plains near the Persian Gulf on the east of the Zagros mountains in the summer to the more mountainous pastures in the west, and back again in the winter. To the east of the Zagros range lies the area of Chahar Mahal from which the bulk of Bachtiari production comes.

Here the actual weavers are a mixture of Kurds, Lurs, Armenian, some say even Turkoman tribespeople. One explanation is that in the early nineteenth century some of the Bachtiari leaders settled in the Chahar Mahal region, where their relative wealth gave them the status of 'gentry'; thus the Bachtiari name was appended to the region and its rug production. The rugs are distinctive and desirable (in spite of their recent misfortune in being copied for machine-made carpeting).

VISAGE: SUNNY, BRIGHT AND CHEERFUL;
GOOD PIECES HAVE A 'BURNISHED'
APPEARANCE. THEY FREQUENTLY MANIFEST
THIS 'BOXED' OR PANELLED APPEARANCE.

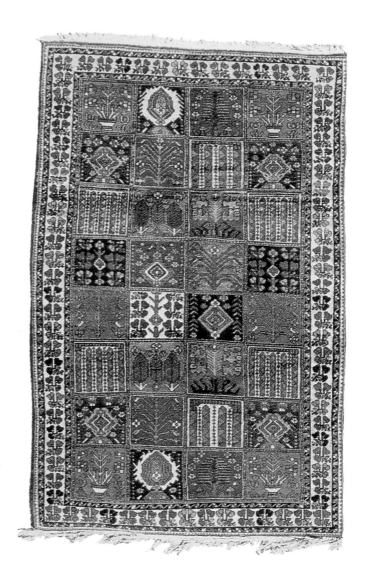

WHICH IS GENERALLY REFERRED TO AS THE 'GARDEN' PATTERN, THE IDEA BEING THAT ONE IS LOOKING THROUGH A WINDOW AT A GARDEN (EACH PANEL CONTAINS STYLISED CYPRESS TREES, OR FLOWERS, OR FOUNTAINS, OR AN UPSIDE DOWN MIRROR IMAGE OF SUCH, HENCE, PRESUMABLY, SOMETHING REFLECTED IN THE WATER OF A POOL). THE TRADE CALL THIS PATTERN KISHTI, ARABIC FOR PANELS OR BOXES.

COLOUR/HUES: BRIGHT TO STRONG ORANGES, RUSTS, WHITE, SOME YELLOWS, WITH A LITTLE BLUE FOR DEFINITION.

TEXTURE: THICK, MEDIUM TO LONG, SPRINGY, EVEN FLUFFY SOFT WOOL.

STRUCTURE: OPEN, COARSE WEAVE; KNOT COUNT (TURKISH) RARELY ABOVE 100 PER SQUARE INCH.

SIZE: RARELY RUG SIZE; MOSTLY 7 X 5 FEET UP TO MAYBE 9 X 6 FEET.

PRICE: A WIDE VARIATION IN PRICE CAN BE EXPECTED, FROM SAY £900 ($1350) (MODERN) FOR 7' X 5', UP TO £3-4000 ($4500-6000) OR EVEN MORE FOR AN OLDER ONE IN GOOD CONDITION.

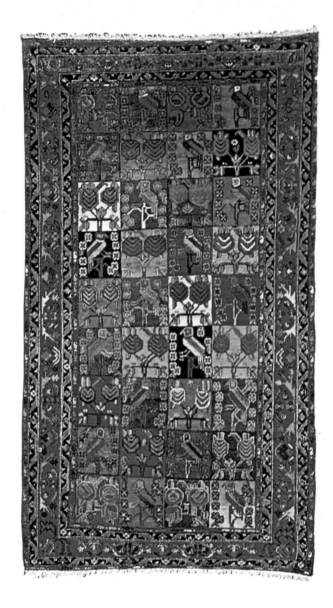

*Right: An
unusually fine
Bachtiar.*

*Opposite: A
typically coarse
Bachtiar.*

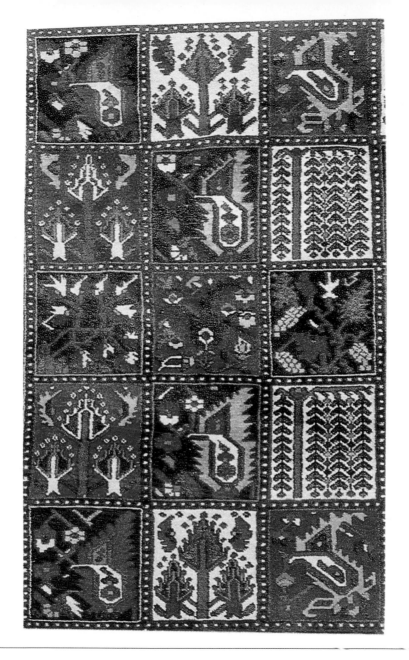

ABADEH (Persian)

Opposite: A black and white photo of an Abadeh showing a typical central panel and the decoration of the corners.

Another member of the southern family you are likely to meet is the Abadeh, characterised by two particular features; a board-like, dense stiffness reminiscent of the Bidjar, and the almost infallible use of a decorative, stylised rose or palmette in all four corners.

VISAGE: DARK AND STRONG; SOMBRE.

COLOUR/HUES: RICH WINE REDS AND DEEP INDIGO TO NEAR BLACK, WITH IVORY, ESPECIALLY IN THE ROSETTES.

TEXTURE: THICK, STIFF, SOLID. NEVER FLUFFY, FREQUENTLY SPIKY.

STRUCTURE: WOOL, MEDIUM TO LONG PILE, WEFTS THICKLY PACKED; OPEN WEAVE WITH AROUND 100 PERSIAN KNOTS PER SQUARE INCH.

SIZE: 5 X 3 FEET AND 7 X 5 FEET.

PRICE: AROUND £900-1250 ($13,500-18,750) FOR A DOZAR.

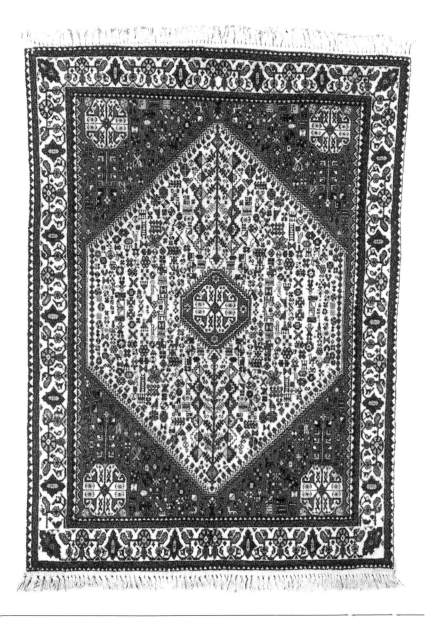

South-west Iran

Now we arrive in the deep south-west, the province of Fars of which the picturesque capital is Shiraz, one of the oldest cities. Shiraz remained untouched by most of the alarums and excursions that beset the rest of the country until the time of the Afghan invasion, and it flourished economically and culturally. Two of Persia's most famous poets, Sa'di (1184–1282) and Hafiz (1320–1389), lived here. Nearby is the architecturally splendid Persepolis.

Shiraz and Quasgai, its close neighbour visually and geographically, both share one interesting characteristic – the inclusion of stylised animals, dogs, birds and so on, not normally found in Persian pieces because the portrayal of living creatures is expressly forbidden by the Koran.

Curiously, this visual element is typically found in rugs from the Caucasus, one thousand miles to the north as the crow flies. Perhaps the most credible explanation is that in the eighteenth century some two hundred thousand people were deported from the Caucasus for being 'ungovernable'. It seems that many of them eventually settled in the south-west, and the assumption is that they brought with them the habit of weaving into their rugs these stray creatures, in some cases even including stylised human figures.

SHIRAZ (Persian)

VISAGE: STRONG, TYPICALLY WITH A 'POLE' MEDALLION. TWO OR THREE DEFINITE BLOCKS OF COLOUR, OFTEN WITH ATTENDANT 'RUNNING HOOK' MOTIF.

COLOUR/HUES: DARK BLUES, STRONG REDS, IVORY, SOME PALE BLUE (RARER).

TEXTURE: MEDIUM PILE, IN MODERN EXAMPLES EVEN HAIRY; BEWARE OF INDIAN COPIES WHICH ARE VERY THICK INDEED.

STRUCTURE: WOOL IN OLDER AND BETTER EXAMPLES IS CLOSE-CROPPED AND FLAT. PERSIAN KNOTS, 50-150 PER SQUARE INCH.

SIZE: MOSTLY ZARONYM AND DOZAR.

PRICE: 5 X 3 FEET, GOOD QUALITY (1920s) IN GOOD CONDITION, AROUND £400 ($600) UPWARDS; MODERN, ROUGH AND COARSE ABOUT £100 ($150).

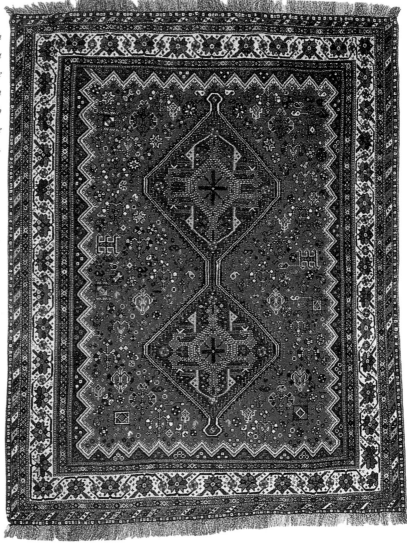

Right: An example of a coarse modern Shiraz with pole medallion.

QUASGAI (*cashkye*) (Persian)

Quasgai are generally considered, as a breed, to be finer and better than Shiraz, visually if not always technically; old ones today are quite eagerly sought after, and are frequently justifiably expensive.

VISAGE: SUNBURNT (SEE STRUCTURE). SIMILAR MEDALLION TREATMENT TO SHIRAZ, BUT MORE COMMONLY MEDALLIONS EMBELLISHED WITH 'RUNNING DOG' PATTERNS AND SOMEWHAT 'PEPPER AND SALTISH' PARTICULARLY AS A RESULT OF 'CHEQUERED FLAG' BORDERS, A TREATMENT SOMETIMES EXTENDED TO THE SPANDRELS. (NOT IN THE EXAMPLE ILLUSTRATED OVERLEAF.)

COLOUR/HUES: EXTENSIVE USE OF IVORY, LESS RED THAN SHIRAZ, PALE BLUES COMMON, WITH INDIGO AND NOT INFREQUENTLY YELLOW; SOME RUST, ORANGE.

TEXTURE: OFTEN SOFT, EVEN 'FLOPPY', MEDIUM-LOW PILE .

STRUCTURE: WOOL; WEFTS MARKEDLY CONTINUOUS IN BROWN/ORANGE GIVE THE 'SUNBURNT' APPEARANCE REFERRED TO ABOVE, PARTICULARLY IN A GENERAL VIEW OF THE BACK. LOW KNOT COUNT, SAY 100-300 (PERSIAN) PER SQUARE INCH.

SIZE: RARELY BIGGER THAN DOZAR.

PRICE: A GOOD OLD DOZAR WOULD FETCH £3000 ($4500) UPWARDS, DEPENDING MOSTLY ON SUBTLETY OF HUES AND COMPLEXITY OF PATTERN.

The name 'Quasgai' provides a colourful example of the diversity of opinion among rug scholars. Generally the tribe is thought to be descended from the Turki but over the centuries other ethnic groups have been mingled in – mostly Arabs and Kurds. The actual origin of the name is explained by three authorities as follows:

1 The first leader of the tribe appointed by Shah Abbas was one Amir Ghazi Shahilu Quasgai.

2 Quasgai is a Turki word used to describe a horse with a white blaze on its forehead. The local people believed that such horses bestowed good fortune on their owners, and such believers were dubbed Quasgai.

3 Kashgar is the name of a Mongol city from which the removal of the ungovernable peoples described earlier took place.

It seems that the tribe is perhaps more reliably identified by its rugs than by its history!

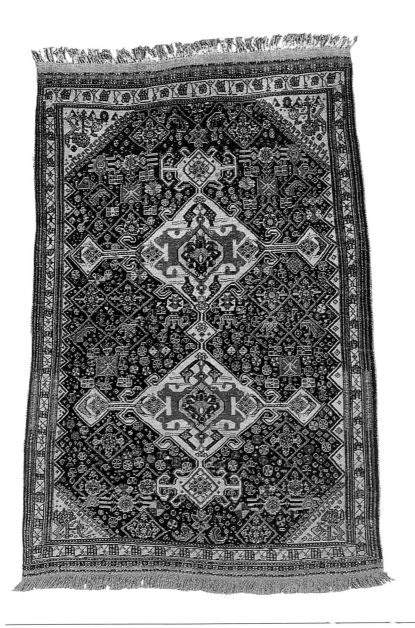

GABBEH (Persian)

VISAGE: UNMISTAKABLY EARTHY. VERY
GEOMETRIC WITH JAGGED DIAMONDS
PREDOMINANT. OPEN FIELDS IN PLAIN
COLOURS. THE TERM 'GABBEH' MEANS
'UNCLIPPED' BUT IT COULD MORE USEFULLY BE
EMPLOYED AS 'UNDYED'. CLASSICALLY THE
RUGS ARE MADE FROM SHEEP WHOSE NATURAL
WOOL IS OF THE COLOURS USED, BUT MORE
RECENTLY THERE ARE DYED EXAMPLES.

COLOUR/HUES: MID-BROWNS, FAWNS, BITTER
CHOCOLATE AND CAFÉ-AU-LAIT, SOME
'OATMEAL' FIELDS. NOW ALSO IN BRIGHT
REDS, BLUE FIELDS AND SO ON.

TEXTURE: THICK, WOOLLY, SOFT.

STRUCTURE: COARSE; LOW KNOT COUNT –
50-100 PER SQUARE INCH, MOSTLY TURKISH.

SIZE: MOSTLY ABOUT 5 X 3 FEET ,
OCCASIONALLY UP TO ABOUT 9 X 6 FEET.

PRICE: AROUND £10-30 ($15-45) PER
SQUARE FOOT.

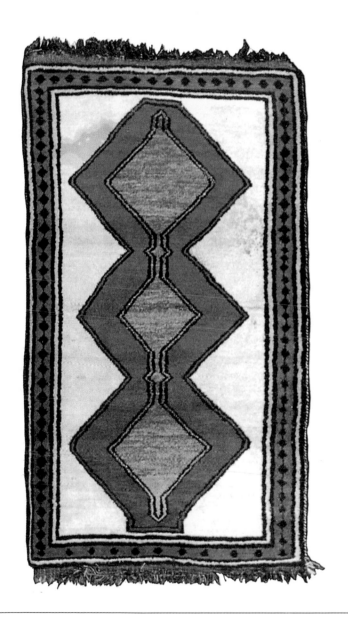

Opposite: An
example of an
Afshar rug.
The pattern is
typically a
reversable
configuration.

AFSHAR (Persian)

Moving on now in an easterly direction, we meet the Afshari; again popularly supposed to have Russian origins. Half of the tribe speak a Turkish dialect and the other half Persian. For some reason, nowadays one meets not nearly as many old Afshars as Shiraz or Quasgai, the bulk of the rugs described as Afshar being modern.

VISAGE: BOLD, STRONG, MEDALLIONS COMMONLY ECHOED IN CONTRAPUNTAL OR REVERSIBLE CONFIGURATIONS AS SHOWN HERE.

COLOUR/HUES: NAVY AND RED WITH IVORY TO THE DETAIL. SOME 'CHEMICALLY WASHED' I.E. BLEACHED AFTER IMPORTATION TO THE WEST. THIS TECHNIQUE PRODUCES SOFTER HUES AND A LOOK OF AGE BUT IT IS SOON RECOGNISABLE ONCE YOU GET YOUR EYE IN: THE GENERAL 'NEWNESS' OF THE RUG GIVES THE LIE TO THE DYE.

TEXTURE: THICK, HAIRY.

STRUCTURE: WOOL, COARSE, OPEN WEAVE, RARELY ATTAINS 100 PERSIAN KNOTS PER SQUARE INCH. LUMPY ON THE BACK. WEFTS RUN OVER AND UNDER GROUPS OF WARPS GIVING A DASH-DASH APPEARANCE.

SIZE: USUALLY DOZAR, MODERN ONES SAY 6 X 4 FEET.

PRICE: £450-600 ($675-900).

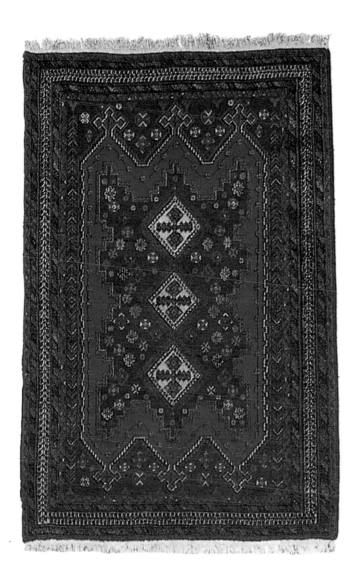

NIRIZ (Persian)

Below: Detail
from the back
of a Niriz.

VISAGE: OFTEN OVERALL PATTERN, AS HERE, FINELY DETAILED.

COLOUR/HUES: WIDE VARIATION OF FIELD COLOUR, OFTEN DARK BLUE.

STRUCTURE: MORE FINELY KNOTTED. PERSIAN KNOTS UP TO 150 PER SQUARE INCH.

TEXTURE: VEERING TOWARDS LEATHERY TO A REMARKABLE EXTENT COMPARED TO ITS GEOGRAPHICAL NEIGHBOURS.

SIZE: MOSTLY RUGS, 6 X 4 FEET.

PRICE: ABOUT £500 ($750) (MODERN).

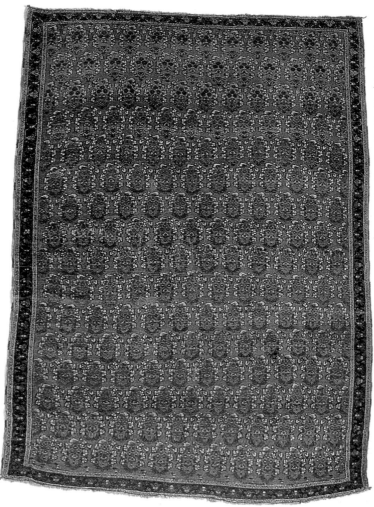

Left: An example of a Niriz which, for a tribal piece, appears to break the rules with regard to the use of what is basically a curvilinear pattern.

KHORASSAN

Opposite:
Detail of the
back of a
Belouch rug.

Now we wing north again, and to the east, to the province
of Khorassan, whence comes a heavy volume of production,
notably Belouch. The Belouchi are a nomadic tribe numbering
about two million souls. They wander a huge area from eastern
Iran to western Afghanistan and produce enormous quantities
of rugs, mostly 5 x 3 feet, usually prayer rugs, and of low
quality. But as a rough, honestly peasant product they have
their own strong appeal, and, being relatively cheap, a few
scattered around in a cottage or a country house can create a
big impact with a small outlay.

The trade tends to classify them as 'Herat' or 'Meshed'. This
obviously has geographical origins but nowadays the term
Meshed is often used simply to denote unusual quality (fineness
in structure) and Herat more run-of-the-mill quality.

The Belouch were, for a long time, regarded as the basic
common denominator of Oriental rugs; in the good old days, if
you bought something 'serious' like an Ispahan, the merchant
would wrap it up in a *ghilim* or belouch, the latter thrown in as
a gesture of appreciation for the business. Not any more.

There are now Belouch collectors, and although, as we have
said, they are mostly of modest quality, rare or older pieces are
fetching big prices (at auctions some old Belouch are fetching
thousands).

BELOUCH

VISAGE: FREQUENTLY SOMBRE BUT OCCASIONALLY VIVID; TYPICALLY A PRAYER RUG WITH STYLISED ARCH. GEOMETRICAL STRAIGHT LINES WITH ANGULAR OR REPEATING MOTIFS AND PATTERNS, LACKING DEFINITION IN DETAIL.

COLOUR/HUES: STRONG, DARK REDS, BLUE-BLACKS, SOME ORANGE, BROWN/FAWN WITH WHITE IN DETAILS AND BORDER OR TO THE PRAYER ARCH.

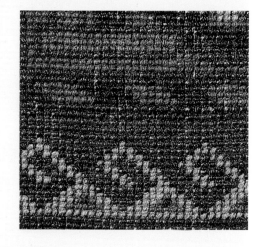

TEXTURE: HAIRY, ROUGH, EVEN SPIKY; MEDIUM PILE.

STRUCTURE: LUMPY ON THE BACK WITH LARGE CRUDE NODES. WEFTS CONTINUOUSLY VISIBLE; OFTEN BROWN OR UNDYED WOOL. KNOT COUNT 50-100 (PERSIAN) PER SQUARE INCH, RARELY MORE.

SIZE: BEING NOMADIC, THE BELOUCHI USE ALMOST EXCLUSIVELY A SMALL PORTABLE LOOM PRODUCING RUGS OF ABOUT 5 X 3 FEET, BUT SOME LARGER EXAMPLES UP TO ABOUT 12 X 9 FEET ARE AVAILABLE AND CAN BE VERY RICH AND EFFECTIVE.

PRICE: £90-120 ($135-180); £1000-1250 ($1500-2000) FOR LARGER EXAMPLES (SEE SIZE).

Right: An old Belouch. Note the ghilim end treatment, commonly a sign of quality in such pieces.

NORTHERN IRAN

Moving now to the extreme north, this is almost where we came in. We complete our *tour d'horizon* with a meeting with one important and currently extremely fashionable breed.

HERIZ (Persian)

The word 'extremely' (above) is used advisedly. In the late 1990s an urge to buy of 'fad' proportions broke out, emanating mainly from the USA, with the predictable outcome of excessively inflated prices. Make no mistake, some Heriz are among the most beautiful and desirable of all tribal pieces. But not all; some more modern examples are rough and coarse to poor in construction.

We have had to restrain several clients from paying exorbitant sums for a piece simply because it bears the tag 'Heriz'. The following remarks apply to good, old Heriz.

VISAGE: CRISP, CLEAR, ECHOING MEDALLIONS
AND OUTLINES SPREAD OUTWARDS FROM THE
CENTRE. EXCELLENT CRAFTSMANSHIP IN THE
DRAWING, ESPECIALLY IN OLDER PIECES. THE
OUTER FIELD IS CHARACTERISED BY A UNIQUE USE
OF STRAIGHT LINE FLOWER STEMS. HERATI MOTIFS
TO WIDE OUTER BORDER.

Opposite: An
exceptionally
fine example of
a Heriz.

Below: A
detail from the
back of the
same piece,
exhibiting
unusually fine
knotting for the
breed.

COLOUR/HUES: BRICK-REDS, PALE AND DARK
BLUES, WITH BEIGE, SOME IVORY, SOME RARE
YELLOWS IN THE DETAIL.

TEXTURE: COARSE BUT 'SOLID'.

STRUCTURE: MARKEDLY PROMINENT WARPS
ON THE BACK, WITH IRREGULAR WEFT
APPEARANCE OF DOT-DOT-DOT-DOT,
FOLLOWED BY LONG DASHES: NOT MANY
TURKISH KNOTS, MAYBE AROUND 100 PER
SQUARE INCH.

SIZE: FREQUENTLY, 15 X 12 FEET AND
BEYOND. OCCASIONALLY SQUARE.

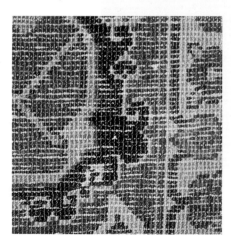

PRICE: VERY HIGH: £10,000
($15,000) FOR A 15 X 12
FOOT CARPET WOULD BE OUR
MAXIMUM FOR A PRIME
EXAMPLE IN GOOD
CONDITION.

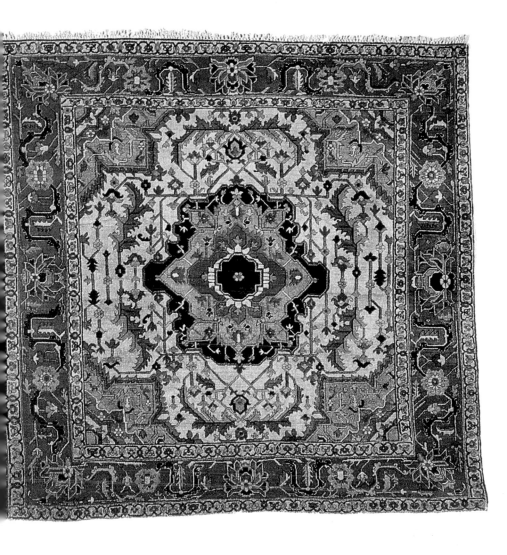

TRIBAL AND VILLAGE FAMILIES -THE CAUCASUS

THE mountainous region of the Caucasus, comprising Azerbaijan, Armenia, Georgia, and Daghestan is the source of a group of rugs which, in the latter part of the twentieth century, leapt to the forefront of attention among amateurs, scholars, and, particularly, collectors. The activities of the latter have resulted in price increases which have frequently been spectacular.

The work that is causing the excitement, mostly the product of the nineteenth and twentieth centuries, displays an individuality of style and a visual identity that sets up walls a mile high between these and other rugs. This visual identity has a uniquely ethnic force and vitality, an entirely suitable reflection of the physical drama of the region, with its huge peaks and valleys, its lochs and lakes and inland seas.

The interest engendered has resulted in the publication of

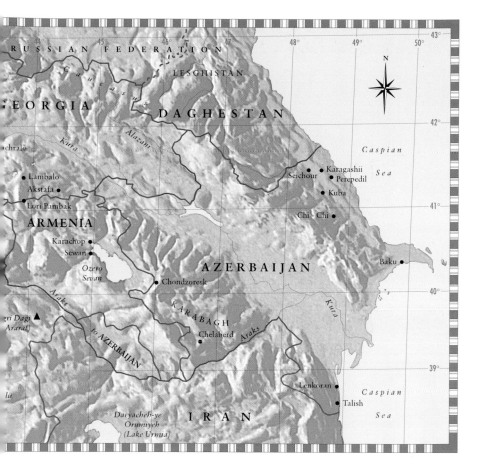

a number of specialist and more or less learned works on the
subject which must speak for themselves; various scholarly
clashes are arising from attempts to classify and sub-divide
the group into types.

One method of categorisation which might be useful
would be by relating the height of the area in question above

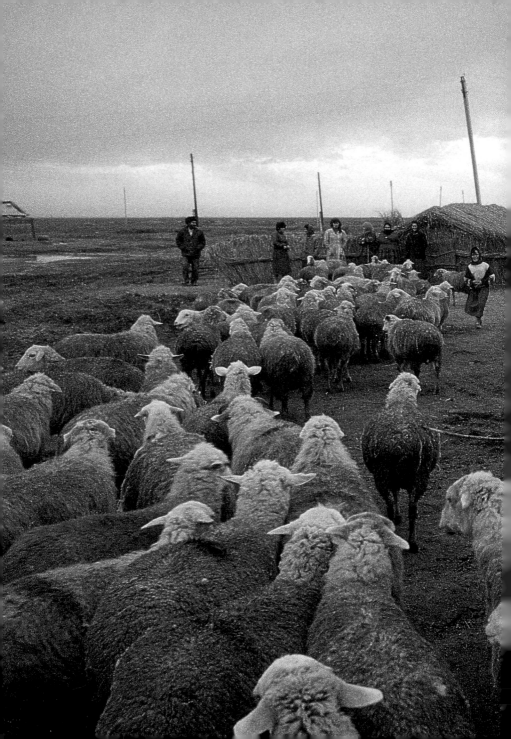

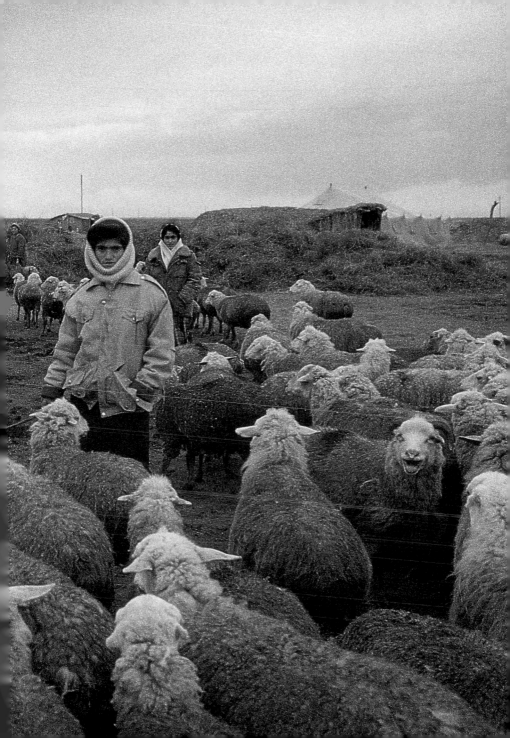

sea level to the pile height in the rugs. This idea is not quite as silly as it sounds: the type of wool varies in proportion according to the area's height, in that sheep reared in the most mountainous parts naturally grow a heavier, shaggier pile than those wandering the lowland pastures. Hence the rugs woven in the mountain villages correspondingly have a thicker and longer pile.

We will thus deal with three broad categories: Kazak, from the western mountains of Armenia and Georgia are (at least in good condition) the longest piled; Karabagh, from Azerbaijan in the east have a medium-length pile; and Shirvan, close-cropped, mostly from the lower parts and sea level areas (the Caspian) of Daghestan in the north-east.

KAZAK

Kazak – the longest piled – display the boldest patterns and almost brutally simple designs. The range of clean, basic colours is limited: blue, red, ivory, green and yellow are the most common. The patterns are large in scale with very little detail. Most common are angular medallions or lozenges, frequently decorated with stylised rosettes; big blocks of colour.

The following are leading members of the Kazak family:

FACHRALO (Kazak)

VISAGE: BOLD, RICH, GLOSSY, FREQUENTLY
PRAYER RUGS, OFTEN WITH EXTENSIVE USE OF
'WINE GLASS' BORDER (THOUGH NOT IN THE ONE
ILLUSTRATED OVERLEAF - SEE KARAGASHLI P00
OR CHONDZORESK P00)

COLOUR/HUES: SUNBURNT, BROWNISH-REDS TO
THE FIELD, WITH CLEAR BLUES, YELLOW AND
IVORY TO THE DETAIL.

TEXTURE: NOTABLE FOR SHEEN; GOOD OILY
WOOL. MEDIUM TO LONG PILE.

STRUCTURE: COARSE OPEN WEAVE, TURKISH
KNOT COUNTS AS LOW AS 70-100 PER SQUARE
INCH, ALTHOUGH CURIOUSLY THIS DOES NOT
SEEM TO PREVENT THE ACHIEVEMENT OF
CONSIDERABLE CRISPNESS IN THE VISAGE.

SIZE: OCCASIONALLY SQUARE; COMMON SIZES
5 X 3 FEET AND 5 X 4 FEET.

PRICE: AROUND £1500 ($2250) UPWARDS FOR
THE BEST PIECES IN GOOD CONDITION.

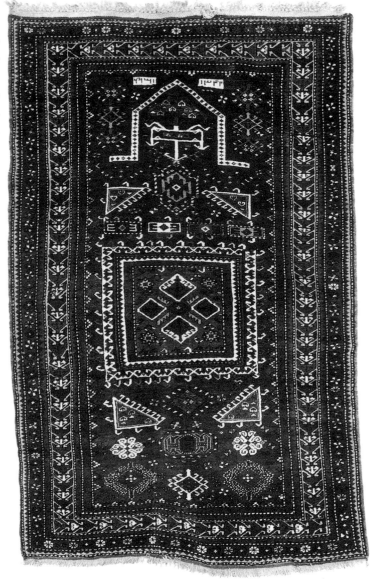

Right: An example of a Fachralo. Note the date panels above the prayer arch.

KARACHOP (Kazak)

VISAGE: SLUDGY. MOST COMMONLY DISPLAYS A LARGE OCTAGON IN IVORY IN RELIEF ON A CENTRAL SQUARE, WITH A SATELLITE SQUARE IN EACH CORNER, BROAD BORDERS DECORATED WITH LARGE SCALE 'RUNNING HOOKS' OR VINE LEAVES. OUTLINES FREQUENTLY LACK CLARITY OR SHARPNESS. THERE ARE SOME GOOD EXAMPLES BUT AN UNFORTUNATE CHARACTERISTIC SEEMS TO BE THE CROWDED APPEARANCE OF TOO MANY ELEMENTS FIGHTING FOR SPACE.

COLOUR/HUES: SUNBURNT, BROWNISH-REDS WITH FLAT BLUES AND QUITE A LOT OF YELLOW IN SOME.

TEXTURE: AGAIN HAIRY, EVEN THICK; GOOD PIECES IN THESE CATEGORIES, THAT IS PIECES IN GOOD CONDITION AND PROBABLY LITTLE-USED, SHOULD BE REALLY FLUFFY LIKE A NEWLY WASHED DOG. THE TRADE DESCRIPTION FOR THIS CONDITION IS 'MEATY'.

STRUCTURE: TURKISH KNOTS, 100-150 PER SQUARE INCH, OPEN COARSE WEAVE.

SIZE: THESE PIECES ARE AMONG THE BIGGEST IN THE KAZAK FAMILY. 8 X 5 FEET IS POSSIBLE.

PRICE: AROUND £3300 ($5000) UPWARDS FOR AN 8 X 5

Note *The spatial relationships of the elements to each other and to the field itself are important – if buying, try to see several before choosing.*

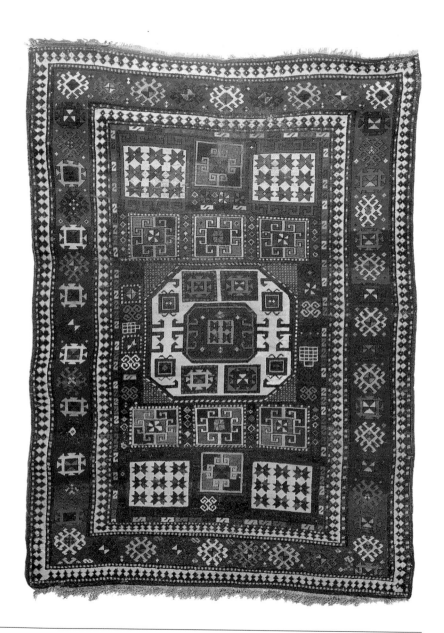

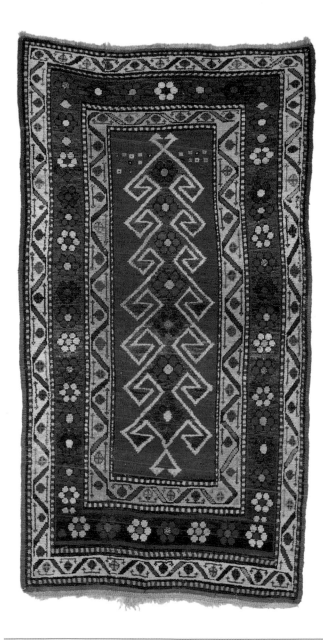

Opposite: An example of a classical Karachop.

Left: A Lambalo. Most Caucasians stick to a single family resemblance: visually there is much less variation than among Persian pieces.

LAMBALO (Kazak)

VISAGE: Distinguished by the unusually wide border treatment leaving no more than a narrow, frequently darkly coloured, panel as the central field; almost always, some form of 'pole' motif.

COLOUR/HUES: Cooler; royal to dark blue, softer reds, ivories and burnt yellow.

TEXTURE: Can be 'floppy'.

STRUCTURE: Open weave, low knot counts (Turkish) 50-100.

SIZE: Typically long and narrow, 6 or 7 feet x 3 foot 6.

PRICE: £1750 ($2600) upwards.

LORI PAMBAK (Kazak)

VISAGE: Bold, strong, even 'hard' or aggressive. Most commonly tri-medallion (as here) . Typically surrounded by running hook motif as here.

COLOUR/HUES: Frequently hard reds, ivories, some greens, bluish-purple in detail.

TEXTURE: Hairy, even spiky.

STRUCTURE: Thick and coarsely knotted (Turkish).

SIZE: Usually middle sized, 6 x 4 feet, 7 x 5 feet.

PRICE: Around £6000 ($9,000) upwards depending on condition.

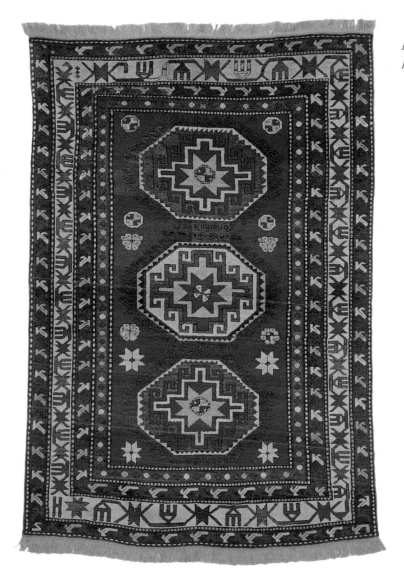

Left: A Lori pambak.

SEWAN (Kazak)

Opposite: A Sewan.

VISAGE: DISTINGUISHED BY THE USE OF ONE LARGE, RUG-FILLING DOUBLE-HEADED MEDALLION LIKE A BUTTERFLY WITH FLOWERS TO RIGHT AND LEFT. OFTEN OUTLINED BOLDLY WITH A LARGE GUARD STRIPE USUALLY IN IVORY.

COLOUR/HUES: DARK, OFTEN FLAT-SEEMING, RUST REDS, SMOKY BLUES, IVORY, WITH SOME USE OCCASIONALLY OF GREENS AND YELLOWS.

TEXTURE: CAN BE FLUFFY BUT ARE COMMONLY THINNER AND FLATTER THAN THEIR COUSINS. INDEED THE PATTERN IS AVAILABLE IN FLAT WEAVE.

STRUCTURE: TWIN WEFTS, LIGHT BROWN WOOL, AND TWIN SELVEDGES. TURKISH KNOTS.

SIZE: MOST COMMONLY DOZAR (7 x 5 FEET), OCCASIONALLY 9 x 6 FEET.

PRICE: A GOOD PIECE WILL COST £4500 ($6750) UPWARDS. MODERN EXAMPLES CAN BE CHEAPER BUT LACK DISTINCTION.

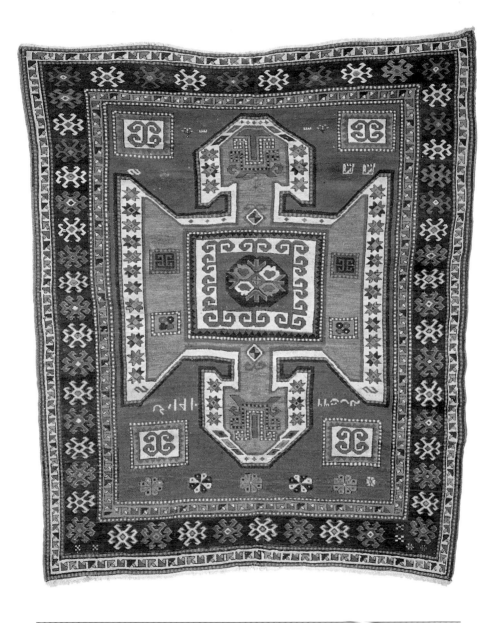

KARABAGH

This family of rugs hails from the south-eastern part of the Caucasus, just north of Iran. Their pile is lower than the Kazaks', but not so close-cropped or dense as their northern neighbours', the Shirvan family.

There is also a tell-tale signature to be found in the weave structure: when you examine the back you will see a double weft between every second row of knots.

The family is represented by some very distinguished breeds, of which the famous Chelaberd must have pride of place.

CHELABERD (Karabagh)

These rugs are also described as 'Adler Eagle' or 'sunburst', referring to the unique 'exploded' medallion, interpreted by some as a stylised version of the Russian coat of arms (a double-headed eagle).

VISAGE: DRAMATIC, VIVID, UNMISTAKABLE; ONCE SEEN, NEVER FORGOTTEN. THE MOST COMMON LAYOUT IS THE MEDALLION FRAMED BY TWO OPPOSING 'FENCES'. A FREQUENT ALTERNATIVE IS TWO 'SUNBURSTS' WITH NO OTHER MAJOR VISUAL ELEMENT.

COLOUR/HUES: STRONG, SUNBURNT, MOST COMMONLY BROWN/BURNT SIENNA TO THE FIELD WITH THE MEDALLION IN IVORY, AND BLUES TO THE DETAIL.

TEXTURE: VARIES SURPRISINGLY WIDELY FROM SOFT TO MUD HARD; BEST EXAMPLES CAN BE REALLY GLOSSY AND OILY.

*Right: A
Chelaberd.*

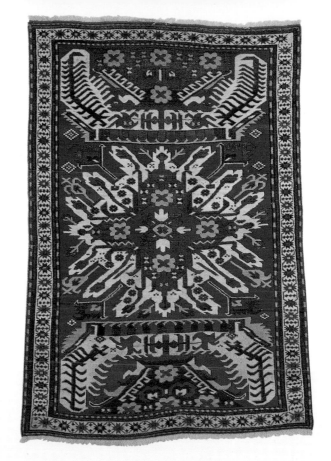

STRUCTURE:
COARSE AND
OPEN TURKISH
KNOTTING BUT
IN SPITE OF THIS THE VISAGE SHOULD BE CRISP.

SIZE: NORMALLY IN THE 7 8 X 5 FEET BRACKET.

PRICE: SHOULD BE HIGH. IF IT ISN'T, BEWARE. THESE RUGS ARE
RECKONED BY MANY TO BE THE APEX OF THE TRIBAL TREE; INVESTORS AND
COLLECTORS WILL QUITE HAPPILY PAY HEAVILY FOR THEM; ANYTHING LESS
THAN £7500 ($11,250) IS UNLIKELY TO BE THE ONE TO BUY.

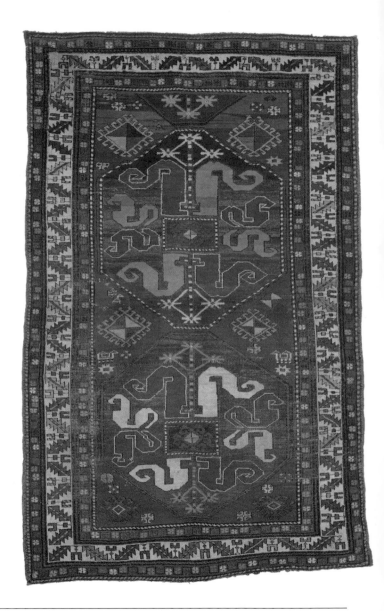

Right: A Chondzoresk or 'Cloud-band' Karabagh.

CHONDZORESK (Karabagh)

VISAGE: BRIGHT, CHEERFUL; SOMETIMES REFERRED TO AS THE 'CLOUD-BAND' KARABAGH WHICH IS UNDERSTOOD TO REFER TO THE DISTINCTIVE WORM-LIKE VISUAL MOTIF.

COLOUR/HUES: A COOL, CLEAR, LIMPID BLUE FREQUENTLY FEATURES; FIELDS IN COOLER REDS, IVORIES AND YELLOWS IN THE DETAIL.

TEXTURE: SOFT, LUMPY.

STRUCTURE: FROM THE STANDPOINT OF STRUCTURE ALONE, SOME OF THESE RUGS WOULD BE DEFINED BY THE PURIST AS KAZAK, IN THAT THEY DO NOT HAVE THE DOUBLE WEFT. LOW TURKISH KNOT COUNTS.

SIZE: CAN BE QUITE LARGE, UP TO AROUND 9 FEET LONG; FREQUENTLY IN A NARROWER FORMAT THAN RECTANGULAR.

PRICE: NO GOOD CAUCASIAN IS CHEAP. THESE ARE AROUND £4500-6000 ($6750-9000) UPWARDS FOR 7 X 5 FEET.

TALISH (Karabagh region)

VISAGE: EASILY RECOGNISABLE BY THE LONG AND NARROW, OFTEN PLAIN OR 'SELF-COLOURED' FIELD RUNNING DOWN THE CENTRE, FREQUENTLY BLUE.

COLOUR/HUES: HEAVY GUARD STRIPES OR BORDERS IN WHITE, IVORY, QUITE HOT REDS.

TEXTURE: MEDIUM PILE.

STRUCTURE: OPEN TURKISH WEAVE, CAN BE THICKISH, NOT STRICTLY KARABAGH STYLE.

SIZE: LONG NARROW FORMAT, THOUGH RARELY LONGER THAN 10 FEET.

PRICE: AROUND £7500 ($11,250) UPWARDS DEPENDING ON QUALITY, CONDITION, AND CLARITY OF DRAWING.

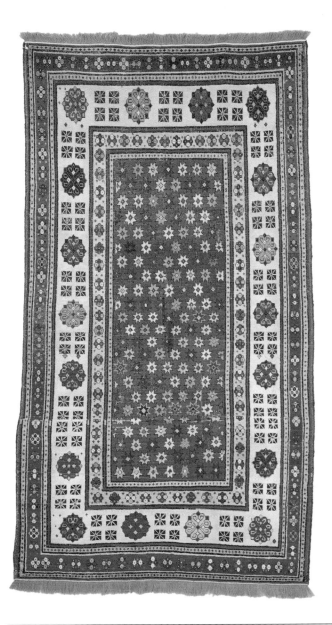

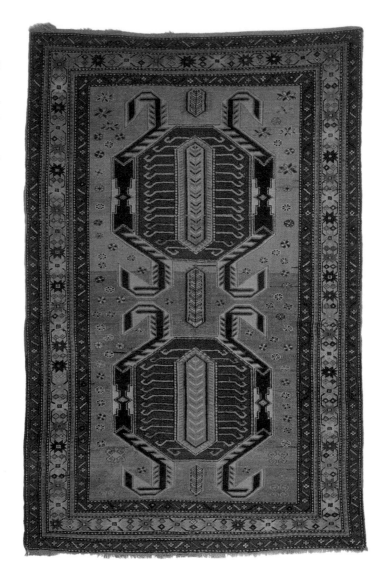

Right: A Lenkhoran showing a huge area of 'abrash' in the bottom half of the field.

LENKHORAN (Karabagh region)

VISAGE: NOTABLY ENTOMOLOGICAL; A DOUBLE OR MULTIPLE 'BEASTIE' MEDALLION WITH 'HORNS' OR 'EARS': A SCARAB.

COLOUR/HUES: VARIED PALETTE RARELY DEPARTING FROM A MIXTURE OF RED BLUE AND IVORY, CRISPLY DEFINED.

STRUCTURE: TALISH (SEE ABOVE) STRUCTURE; AGAIN NOT STRICTLY KARABAGH EXCEPT GEOGRAPHICALLY. TURKISH KNOTS.

SIZE: AGAIN, NARROWER FORMATS ARE COMMON. WELL-DRAWN PIECES CAN BE VERY DESIRABLE WITH A STRONG IMPACT.

PRICE: AROUND £4500 ($6750) UPWARDS FOR A 9 X 3 FOOT 6.

MOGHAN (Karabagh region)

VISAGE: SO FAR AS WE KNOW, THE MOGHAN DISTINGUISHES ITSELF IN THAT IT NEVER ALTERS FROM THE SOMEWHAT BORING FORMULA SHOWN OVERLEAF.

COLOUR/HUES: RUSTY REDS, ORANGE, CHALKY WHITES, DARK AND MID-BLUES.

STRUCTURE: TIGHTLY KNOTTED, 1-200.

TEXTURE: FIRM.

SIZE: MOST LIMITED TO THE LONG, NARROW FORMAT, SAY 8-9 X 3 FOOT 6.

PRICE: ABOUT £2500 UPWARDS.

Right:
A Moghan.

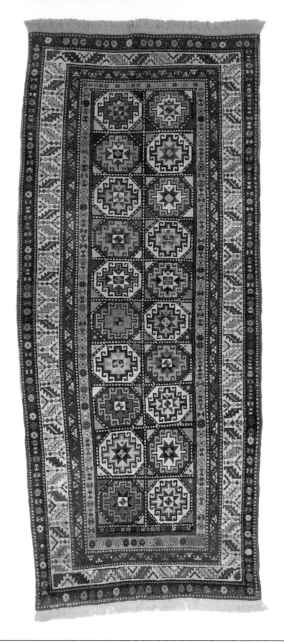

ORIENTAL RUGS

SHIRVAN

This 'family', in contrast to all other Caucasians, are more densely knotted, close-cropped and 'leathery' to the touch. Many have a very distinct visage with which you will soon become familiar. But beware. There are obvious copies about, which you will easily spot since they are quite the wrong colour and texture: usually thick and floppy and mostly Indian.

Just the other day I came across a 'Perepedil' at an auction viewing. It had the right colours and patterns so had been catalogued as Perepedil, but at nearly three-quarters of an inch thick, it was clearly no such thing. This is the sort of situation in which your fieldwork (see Chapter 9) will pay handsome dividends; if your friendly retailer has been able to let you handle a real Perepedil (there aren't too many about) you will never again mistake the wrong for the right.

I had a lady 'apprentice' who, at an early stage, came back to the gallery one day in great excitement with a 'Caucasian' she'd snapped up at auction for only £300 ($450). It was in fact a thick, poor Turkish Yacebedir. Although it was very 'Caucasian' in visage I couldn't understand how she had made such a mistake until I realised that she had not, at that stage, handled any Caucasians. A little *tactile* education would have saved her embarrassment. She put the offending piece into another auction where it fetched £125 ($200). A relatively cheap, but none the less memorable lesson.

AKSTAFA (Shirvan)

VISAGE: CLEAR AND SHARP.
MOST EXAMPLES UNMISTAKABLE
BECAUSE OF THE DOMINANT,
STYLISED 'PEACOCK TAIL'
PATTERN, SURROUNDING
BASICALLY RECTANGULAR
MEDALLIONS VARIOUSLY
DECORATED. FINELY DETAILED,
RHYTHMIC BORDERS.

COLOUR/HUES: TYPICALLY A
DARK FIELD, BLUE OR NAVY,
SHOWS OFF THE IVORY TAIL
FEATHERS. MID-RUSTS TO THE
MEDALLIONS, WITH SOME RED,
PALE BLUES AND YELLOW IN
THE DETAIL.

TEXTURE: DENSE, WIRY. VERY
TOUGH AND LEATHERY.

STRUCTURE: TURKISH KNOTTING. 100 UPWARDS PER SQUARE FOOT.

SIZE: THE AKSTAFA ARE OFTEN FOUND IN THE RUNNER FORMAT, UP TO
ABOUT 9 OR 10 FEET IN LENGTH. THEIR TOUGHNESS SUITS THEM FOR
RUNNER SITUATIONS BUT THEIR VALUE WOULD MAKE SOME HESITATE TO
USE THEM IN SUCH A SITUATION.

PRICE: FOR A 9 X 3 FEET, SAY £9000 ($13,500) UPWARDS.

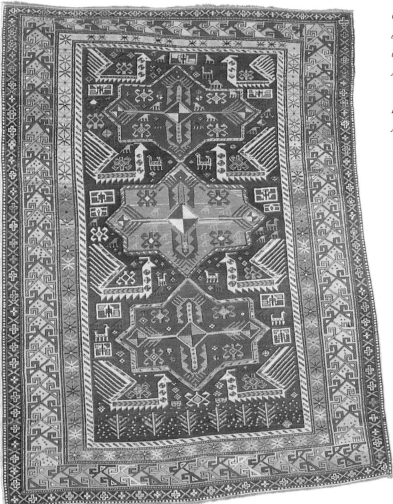

*Opposite: A
detail from the
back of an
Akstafa.*

*Left:
An Akstafa.*

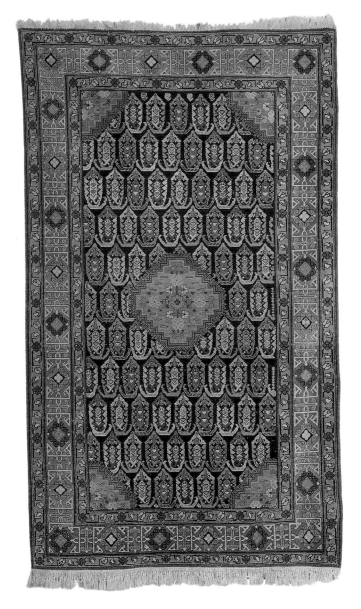

Right: A Baku.

Opposite: Detail from the back of a Baku.

BAKU (*bakoo*) (Shirvan)

VISAGE: AMONG THE BEST OF THE SHIRVAN, MOSTLY BEARING AN OVERALL BOTEH PATTERN, WITH MEDALLION.

COLOUR/HUES: BLUES, FROM PASTEL TO TURQUOISE, SOME WITH BRIGHT WHITE SELVEDGES.

TEXTURE: CAN BE THICKER THAN OTHER SHIRVANS.

STRUCTURE: WARPS OFTEN MADE WITH DARK GOAT'S HAIR, AND WEFTS USUALLY BROWN; KNOTS TURKISH.

SIZE: RUGS, OCCASIONALLY KELEYS.

PRICE: FOR A 6 X 4 FEET, AROUND £2000 ($3000) UPWARDS.

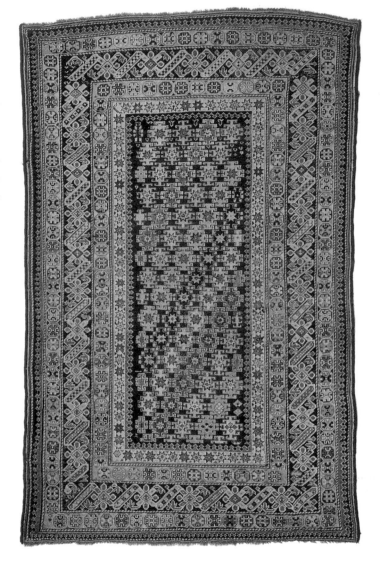

Right:
A Chi-chi.

Opposite:
Detail from the
back of a
Chi-chi rug.
Note the
distinctive
'hair pin' weft
pattern.

CHI-CHI (Shirvan)

VISAGE: PEPPER AND
SALT, ARISING FROM
THE SHARP IMPACT OF
A MULTITUDE OF TINY
ELEMENTS IN THE
DRAWING, USUALLY
HEIGHTENED BY
SEVERAL DENSELY
PACKED BORDERS OR
GUARD STRIPES,
FREQUENTLY
MANIFESTING THE BAR
MOTIF.

COLOUR/HUES:
IVORIES, FLAT REDS, A CURIOUS BLUE WHICH FROM CERTAIN ANGLES AND
IN CERTAIN LIGHTS THROWS OFF A GREENISH GLOW.

TEXTURE: SOFTER THAN THEIR COUSINS.

STRUCTURE: A MORE OPEN WEAVE THAN THEIR COUSINS; TURKISH
KNOTS, AROUND 100 PER SQUARE INCH.

SIZE: SOME SMALL SIZES BUT USUALLY 6 X 4 FEET OR 7 X 5 FEET.
COLLECTORS ARE KEENER ON THESE THAN THE GENERAL PUBLIC WHO
TEND TO FIND THEM 'BUSY'. AN ACQUIRED TASTE.

PRICE: AROUND £9000 ($13,500) UPWARDS FOR A 7 X 5 FEET.

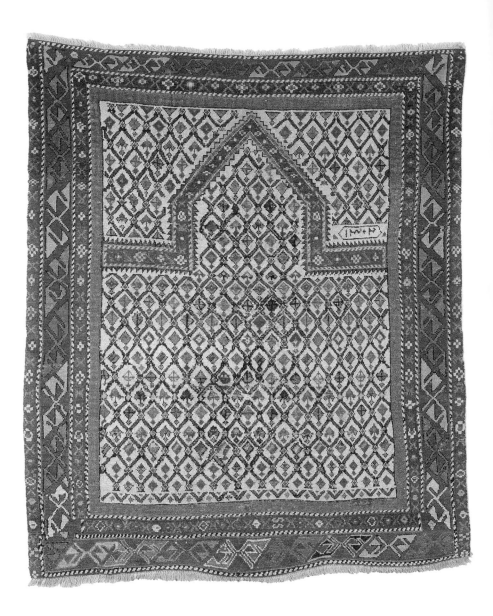

DAGHESTAN (Shirvan)

Opposite:
A Daghestan
prayer rug
dated 1302
Hejira. Deduct
3% (39) and
add 622 to
reach 1885
Gregorian.

VISAGE: CRISP AND CLEAR, THE FIELD CRISS-
CROSSED WITH RHYTHMICALLY REPEATED
ELEMENTS. STYLISED FLOWER HEADS OR
PALMETTES, FREQUENTLY DIAGONALLY BOXED.

COLOUR/HUES: OCHRES, MUDDY RED, WITH NAVY
AND IVORY IN THE DETAIL. MOSTLY IVORY FIELDS.

TEXTURE: WIRE-HAIRED, OFTEN STIFF.

STRUCTURE: CLOSE-CROPPED, MORE DENSELY
KNOTTED THAN ITS COUSINS AT UP TO 200 KNOTS
PER SQUARE INCH.

SIZE: YOU ARE MOST LIKELY TO MEET THESE IN
PRAYER RUG FORMAT AND SMALL SIZES – 5 X 3
FEET. VERY BEAUTIFUL IN GOOD CONDITION.

PRICE: RARISH AND MUCH SOUGHT-AFTER AT
PRICES LIKE £4500 ($6750) UPWARDS.

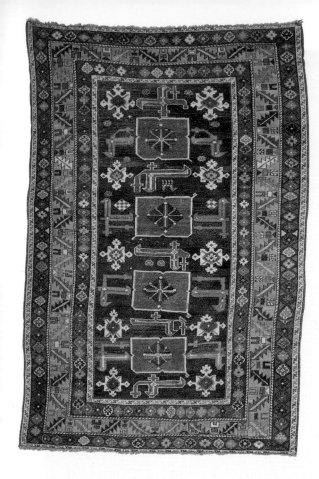

KARAGASHLI
(Shirvan)

VISAGE: A CRISP, PLEASANTLY RICH EFFECT PRODUCED BY LAYING THREE OR FOUR RHOMBOIDS OF A CLEAR ALMOST PILLAR BOX RED ON AN INKY INDIGO FIELD WITH SOME RESTRAINED DECORATION, THE FIELD FREQUENTLY PEOPLED BY LITTLE STYLISED DOGS.

COLOUR/HUES: TO THE RED AND BLUE ARE ADDED IVORY, NAVY, BLUE-BLACK AND OCHRE COMMONLY TO THE BORDERS.

TEXTURE: MORE SYMPATHETIC TO THE TOUCH THAN SOME COUSINS; CAN BE THICKER TOO THAN THE REST OF THE FAMILY.

STRUCTURE: TURKISH KNOT COUNT CAN ATTAIN 150 PER SQ. INCH.

SIZE: 5 X 3 FEET, 6 X 4 FEET.

PRICE: SOME WOULD SAY CHEAP AT £4500-7500 ($6750-11,250).

KUBA (*kooba*) (Shirvan)

VISAGE: A CURIOUS MEDALLION TREATMENT, AND AN EXPLODED 'RUNNING DOG' BORDER, ARE THE CHARACTERISTICS OF THE RUGS MOST GENERALLY ACCEPTED AS 'KUBA', ALTHOUGH A WIDE VARIETY OF VARIANTS WILL BE DIFFERENTLY ATTRIBUTED BY DIFFERENT PEOPLE.

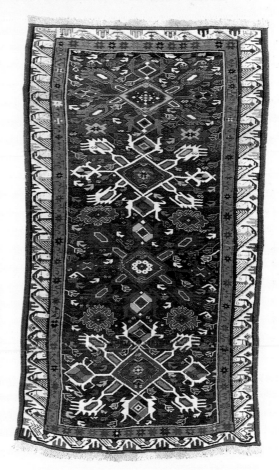

COLOUR/HUES: STRONG, ALMOST HEAVY BLUE-BLACK FIELDS. VIVID COMBINATIONS OF CHALK WHITE AND ORANGE.

TEXTURE: DENSE.

STRUCTURE CLOSE-CROPPED. WARPS PALE BROWN, DOUBLE WEFTED. AROUND 100 TURKISH KNOTS PER SQUARE INCH.

SIZE: TEND TO HAVE LONG NARROW FORMATS, 6 X 3 FEET, 7-8 X 3½-4 FEET

PRICE: £2000 ($3000) UPWARDS.

LESGHI (*leshkey*)
(Shirvan)

VISAGE: SOMETIMES LESS
CRISP THAN ITS COUSINS,
POSSIBLY THANKS TO THE
INNER/OUTER DOUBLE STAR
MOTIF AND ITS SHADING
WHICH LEADS THE EYE IN
TWO DIRECTIONS AT ONCE.
THE MOTIF IS A SORT OF
RECTANGULAR VERSION OF
THE 'ADLER EAGLE' (SEE
CHELABERD).

COLOUR/HUES: MOST
COMMONLY USES THE SAME
PALETTE AS THE KARAGASHLI,
WITH STRONG REDS AND
BLUES. OCCASIONALLY THE
EFFECT IS ACHIEVED BY THE USE OF BROWNS AND ORANGES, BUT NOT
NEARLY SO PLEASING.

TEXTURE: HIRSUTE, DENSE-SEEMING THOUGH NOT ALL THAT FINE IN
STRUCTURE.

STRUCTURE: AROUND 75-100 TURKISH KNOTS PER SQUARE INCH.

SIZE: FREQUENTLY IN LONG NARROW FORMATS, E.G. 9 X 4 FEET.

PRICE: A 9 X 4 FOOT IN GOOD CONDITION COULD COST £9000
($13,500) OR MORE IF WELL DRAWN.

PEREPEDIL (Shirvan)

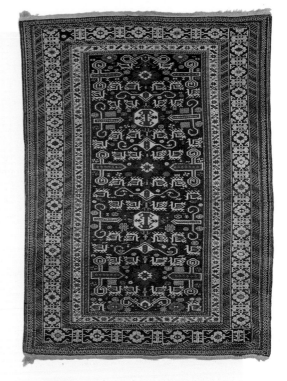

VISAGE: VERY CRISP. STRIKINGLY INDIVIDUAL MOTIF KNOWN AS THE 'RAM'S HORNS' IN TWO VARIATIONS: THE VERTICAL WITH A CENTRAL BAR OR SPINE CROSS-WISE IN THE MIDDLE, AND THE HORIZONTAL CLOSELY RESEMBLING HANDLEBARS. ANOTHER COMMON DETAIL IS A SOLID-BODIED MYTHICAL CREATURE WITH TWO PAIRS OF CRISS-CROSSED LEGS AND A LOCH NESS MONSTER NECK ON WHICH IS PERCHED A TINY HEAD.

COLOUR/HUES: ALMOST INVARIABLY A DARK NAVY FIELD IS USED TO HEIGHTEN THE IMPACT OF THE RAMS' HORNS, SHARPLY OUTLINED IN CARMINE AND DAZZLING WHITE.

TEXTURE: CAN BE GLOSSY AND MEATY.

STRUCTURE: VERY TIGHT; ONE OF THE BEST OF THE FAMILY STRUCTURALLY WITH OVER 100 KNOTS PER SQUARE INCH.

SIZE: 6 X 4 FEET, 7 X 5 FEET.

PRICE: A REALLY EXCELLENT 7 X 5 FEET COULD BE AROUND £9000 ($13,500) UPWARDS.

SEICHOUR (*say-sure*) (Shirvan)

VISAGE: TYPIFIED BY A REPEATING OPEN-ARMED MEDALLION, ALTERNATIVELY READABLE AS A SERIES OF CROSSES. CAN BE MUDDY, SOMEWHAT CROWDED, ALTHOUGH VERY RICH ON INITIAL IMPACT. THE BORDER USUALLY DISPLAYS A UNIQUE BOTEH-LIKE MOTIF WHICH CAN BE INTERPRETED ALTERNATIVELY AS A BEAKED BIRD'S HEAD.

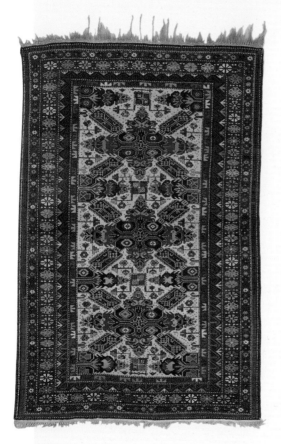

COLOUR/HUES: MID-BROWNS AND COOL ORANGES NOT UNUSUAL WITH DARK BLUES, IVORIES, A CERTAIN 'GREEN' SHEEN IN SOME EXAMPLES.

TEXTURE: GOOD TO FAIR; A LITTLE UNYIELDING.

STRUCTURE: 100 KNOTS (TURKISH) PER SQUARE INCH.

SIZE: LONG FORMATS ARE COMMON, UP TO 10 X 4 FEET.

PRICE: A 10 X 4 FEET PIECE COULD COST £7500 ($11,250).

Before leaving the Caucasians, and in spite of the stated intention of simplification, it is hard to resist one fascinating detour.

Most observers appear to agree that historically the earliest carpets attributed to the Caucasus were the so-called 'dragon' and 'floral' carpets. These are, to my eye at least, anathema to the simple vitality that we have seen so far and that is now so much admired. The 'dragon' and 'floral' carpets have a formality and density of pattern that is almost 'Western', or certainly more closely akin to 'city' pieces than it is to the drama of open fields and the solid colour blocks we expect to see in Caucasians.

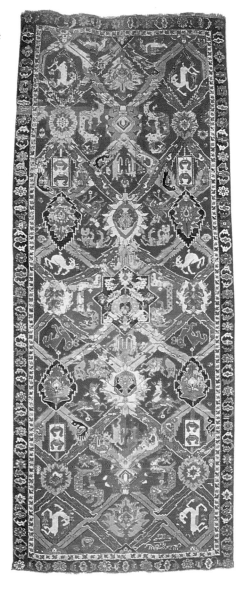

Left: A 'Dragon' rug.

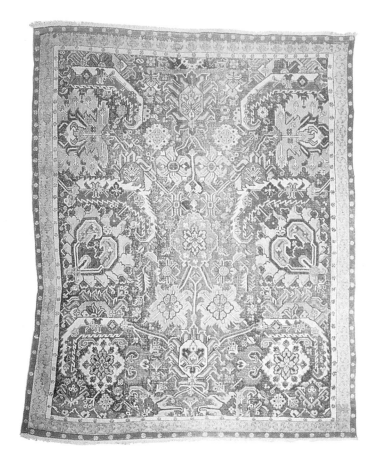

The establishment of a hereditary design connection between these early formal designs and the much more vital later pieces seems highly questionable, requiring a quantum leap of a kind not normally associated with such concepts as the gradual transition and development of visual imagery handed down, albeit with corruptions, from generation to generation.

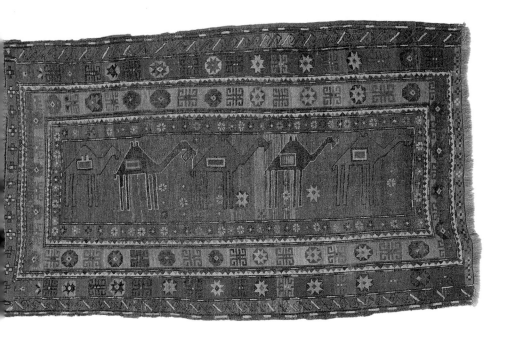

The question therefore is, if the camel rug (*above*) developed from the floral one (*left*), is this a process of sophistication in reverse? If the process of 'sophistication' brought us from the first faltering notes played on a hand-whittled reed to Beethoven's Ninth or from the rudimentary cave drawings to the work of the Grand Masters, or indeed, from the abacus to the computer, why are the people of the Caucasus heading in the opposite direction? In another dimension, you could compare this to Picasso's achievement in throwing the book away to develop the child art of a master craftsman.

Are these 'primitives' primitive, or are they a highly developed art form?

Above: The Camel rug: Primitive or sophisticated? (Note the prominent 'abrash'.)

TRIBAL AND VILLAGE FAMILIES -
TURKMENISTAN

SO far as we are aware the early psychologists
did not study Oriental rugs and carpets, but if
they had, they would surely have reached
some pretty swift conclusions about the personal
proclivities and characteristics of the Turkoman
tribes who inhabit the region to the east of the
Caspian, and south of the Aral seas.

Personality theories have categorised people as
'hysteric' and 'obsessive'. The hysteric is outgoing
and carefree and the obsessive introspective, cautious,
and disciplined – the sort of person who is forever
taking the change out of his pocket and rearranging
the coins in order of size in the palm of his hand.
Psychologists would have found plenty of case
evidence among the Turkoman tribes who were obsessive to the
nth degree, every last one of them: the entire output of these
tribes, whether animal trapping, bag or rug, is inevitably
stamped with rows of regimented gül motifs.

The Turkoman were the Victorians of the north, producing

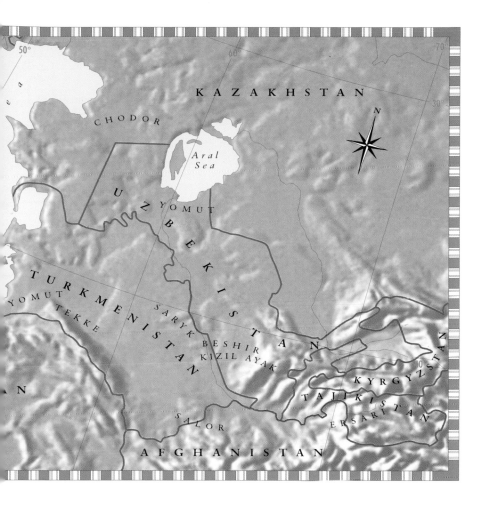

an incredible array of woven paraphernalia, an unrivalled
quantity of knick-knacks. The floor of the *yurt* (a semi-
permanent circular tent with a wooden frame) in which they
lived was always piled high with weavings and trappings, and
the walls similarly decorated.

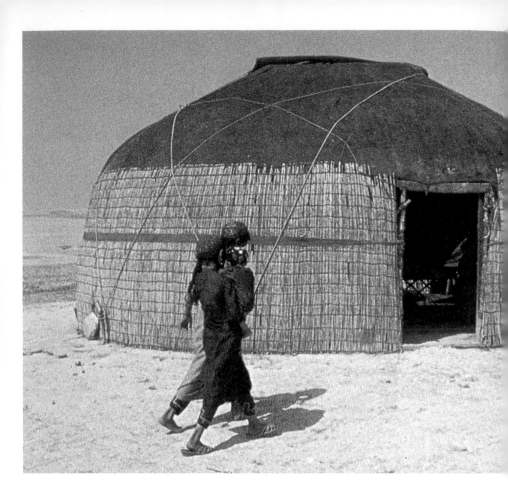

They not only had a special woven bag for their bread, they had a bag for the comb and one for the salt and one for the mirror. They had bags to keep the bags in. They produced pentagonal woven covers to decorate the knees of camels participating in a wedding procession. The antimacassar pales into insignificance!

Having said all that, it must be noted that the Turkoman are entitled to considerable respect, for the quality of their production was extremely high; indeed, structurally, close to the highest quality of any tribal product.

It's something of a mystery that most of the output you will come across from this region is relatively modern; pieces older than antique (100 years plus) are rarer than those from other sources. Nor is it really possible to explain away this phenomonen by reference to the remoteness of the area from commercial traffic, because Bokhara itself, the market centre from which the bulk of these goods came, lies only about a hundred miles to the north of the ancient and romantic 'silk' route.

It seems probable that the earliest 'commercial travellers' found the flat orthodoxy of these items uninteresting, and they might well have been right; they would certainly have seemed out of place in the ornate drawing rooms and salons of eighteenth-and nineteenth-century Europe, with their Aubussons, chandeliers, Gobbelin and Verdure tapestries. It is indeed only during recent times that significant numbers of people have become seriously interested in the Turkoman breeds as an area of specialisation, worthy of collection and investment, but the general wave of interest in this as in other ethnic sources has long since pushed interest and hence prices into the higher brackets.

Opposite:
A yurt,
Turkmenistan.

Previous pages:
Kirghiz women
cooking inside
a yurt,
Afghanistan.

And there is more to all this than meets the eye. The repeated *gul* or stylised flower head which infallibly typifies this produce varies in outline. Rather like a cattle brand, each gul identifies the tribe that made it. Important tribes include the Beshir *(baysheer)* and Kizil Ayak *(aye-ak)* This clear-cut discipline, among other things, gives the pieces a characteristic not always found in other hand-woven Oriental pieces; their provenance is rarely questionable, and this is a definite attribute in an investment situation.

Right: A few of the Turkoman guls.

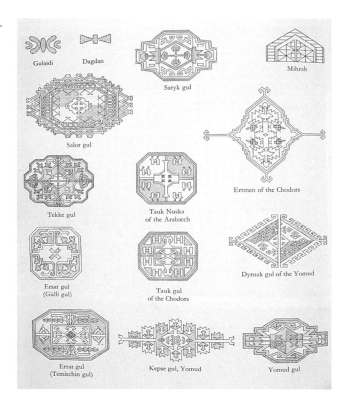

Gulaidi
Dagdan
Mihrab
Saryk gul
Salor gul
Ertmen of the Chodors
Tekke gul
Tauk Nuska of the Arabatch
Ersar gul (Gülli gul)
Tauk gul of the Chodors
Dyrnak gul of the Yomud
Ersar gul (Temirchin gul)
Kepse gul, Yomud
Yomud gul

TEKKE BOKHARA (Turkoman)

The flagship of the line, to most observers, is the product of the Tekke (*tekky*) tribe.

VISAGE: SOFT, GLOWING, PEACEFUL. THREE, OR OCCASIONALLY, FOUR ROWS OF GULS ARRANGED, AS THE EXAMPLE OVERLEAF, IN DISCIPLINED ROWS. QUALITY IS TO BE JUDGED OBVIOUSLY BY THE FINENESS OF THE KNOTTING, BUT ALSO PARTLY BY THE SPATIAL RELATIONSHIP OF THE GULS, ONE TO ANOTHER AND ALL TO THE OVERALL FIELD; CRITERIA WHICH ARE PLACED UNDER THE MAGNIFYING GLASS BY THE DISCIPLINED REGIMENTATION OF THE ELEMENTS. OVERCROWDING IS BAD; OLDER PIECES HAD FEWER AND BIGGER, MORE SPACIOUS GULS THAN THE MODERN OUTPUT.

COLOUR/HUES: STRONG TO MEDIUM MADDER REDS, CLARETS, BURGUNDIES, WITH 'TERRACOTTA', IVORY AND BLACK TO THE DETAIL OF THE GULS AND BORDERS. IN OLDER EXAMPLES THE HUE OF THE FIELD ITSELF MELLOWS TO THE COLOUR OF LIVER OR TO 'TERRACOTTA'.

TEXTURE: HARD, LEATHERY, BUT OCCASIONALLY VELVETY (YOUNGER WOOL).

STRUCTURE: THE WARPS APPEAR TO PREDOMINATE IN THE STRUCTURE, PARALLEL PAIRS VERY VISIBLE. WEFTS FREQUENTLY BROWN, CAN BE FINE TO VERY FINE, WITH SOME PIECES REACHING 2-300 PERSIAN KNOTS PER SQUARE INCH.

SIZE: FROM 5 X 3 FEET UPWARDS, RARELY, IF EVER,
BIGGER THAN THE HALI OR MAIN, CENTRAL CARPET,
ABOUT 12 X 9 FEET.

PRICE: A REALLY EXCELLENT EXAMPLE (IN TERMS OF
DRAWING AND USE OF SPACE AND FINENESS OF
KNOTTING) IN THE BIG SIZE, FROM THE END OF THE
NINETEENTH CENTURY, WOULD START AT ABOUT £9000
($15,000) AND VARY A LONG WAY UPWARDS DEPENDING
ON CONDITION.

All of the foregoing remarks would apply to the other
members of the family, except as to visage, which will vary
according to the tribal gul shape.

All of these are loosely referred to by some a 'Bokhara'. The
term is more correctly applied only to the Tekke. The correct
family name is Turkoman, which of course is also applied to
Bokhara. Thus a 'Tekke Turkoman Bokhara' is a correct
description, as would be a 'Turkoman Yomud', 'Turkoman
Ersari', 'Turkoman Salor' and so on.

These pieces frequently formed part of a dowry, and so the
weaver laboured long and with unusual care over the piece, to
impress his new relatives.

In present times, sympathetic hue, indicating the use of the
proper dyes, and fineness of structure are the criteria applied for
valuation purposes and can result in differences of up to 100
per cent in price between two otherwise directly comparable pieces.

To prove that we weren't romancing at the beginning of this
chapter, here are a mere handful of the animal trappings
produced...

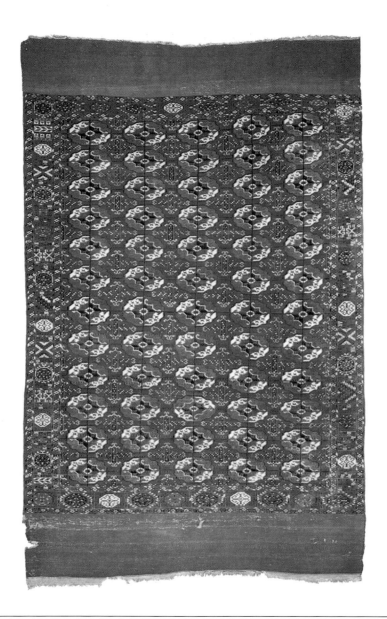

1

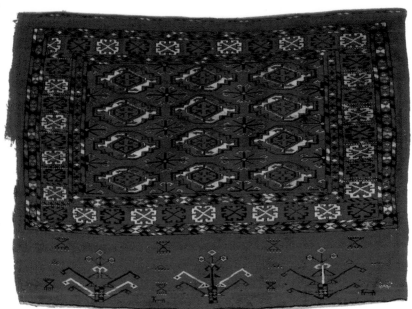

2

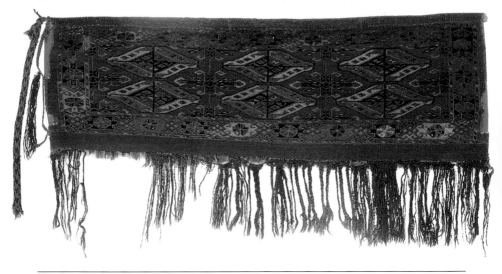

ORIENTAL RUGS

4

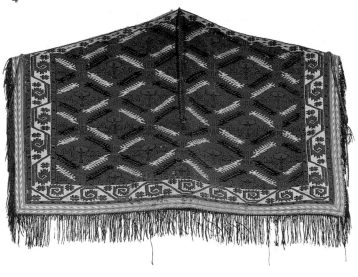

3

5

1. *Chuval: bag face, usually about 5ft x 3 ft*
2. *Germech: there is some controversy over the original function of this piece. Some say it was part of the set of decorations for the doorway, see Engsi etc., but there is no certainty.*
3. *The kapunuk was clearly a door surround, and the (4.) asmalyk decorated the camel's flanks;*
5. *the ok-bash seems to have been a sort of quiver, a theory supported by the fact that these are Turkish words translating to "arrow-head".*

TURKEY AND OTHER SOURCES

TURKEY

HISTORICALLY the fulcrum between East and West, between Asia and Europe, Turkey's shores are, refreshingly, washed by four seas, the Mediterranean, the Aegean, the sea of Marmara and the Black Sea. For our purposes however, the rug production is neither historical nor refreshing, with two notable exceptions.

Although Turkey has produced rugs – some of outstanding quality – since about 1400, including the famous Dragon and Phoenix rugs, you are unlikely to come across anything of more than modest quality today unless it is a silk Hereke (*herrikay*).

A master weaver called Zareh Penyamin is reported to have made a silk Hereke prayer rug of 2500 knots per square inch, so incredibly fine and clipped so short that it could be folded and put in his pocket. Good Hereke are among the finest silks you can buy. They are frequently but not infallibly distinguished

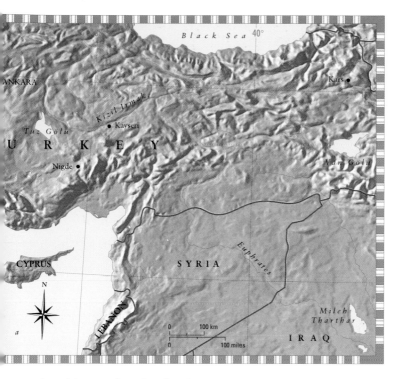

by a 'signature' mark, often in a corner.

Hereke rugs have a subtle richness of visage which delights the eye, employing most often soft autumnal hues with gold, the palest of blues, silver and ivory to the detail. They can be rolled diagonally from the corner like a sheet of thin rubber, and when you let go, they will spring back with supple elasticity, except for those that are interwoven with fine metallic threads of gold or silver (a not uncommon but distinctive characteristic of the breed). They are mostly small (3 x 2 feet), rarely larger than zaronyms. A good zaronym Hereke will cost you at least £3000 ($5000).

Right: A Hereke.

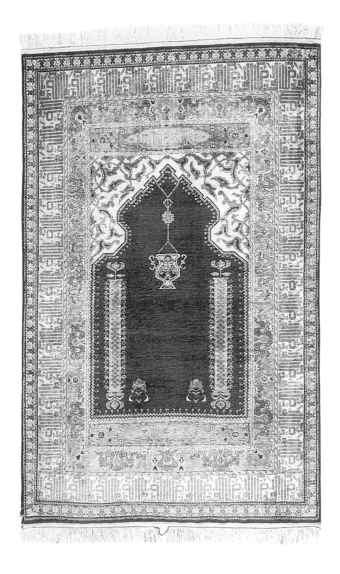

*Left: Ghiordes
with prayer
arch and
'Light of
Mohammed'.*

*Right: Kayseri,
almost
certainly an
example of the
ersatz 'artsilk'.*

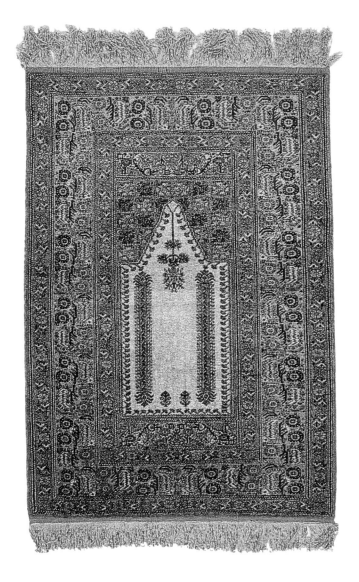

There are also wool Hereke, curiously of only moderate to poor quality, new goods classed in the trade as 'commercial' – around £15 ($25) per square foot.

Rugs are believed to have come from Bergama as early as the thirteenth century. It was one of the main production sources, to which the rugs appearing in the paintings of Holbein are often attributed.

Again modern produce is woefully below previous standards of quality, mostly 'commercial'. Other rugs belonging to this group that you are likely to meet are Ezineh (*ayzeenay*), very coarse, and the Yacebedir (*yachibedeer*), flat and lacking inspiration.

Bursa are rarely encountered these days. The town of Broussa was in earlier times a noted centre for the production of fine, mostly silk, pieces.

An old favourite from Victorian times is the 'Turkey' carpet: the cheerful, bright scarlet, thick carpet with vivid blue, green and black repetitive pattern – the tarantula. These are again popular and come in big sizes, frequently runners. In good condition, they could cost around £10 ($15) per square foot.

From Ezineh (*ayzeeneh*) and Kars come rugs of ordinary quality although occasionally quite pleasing to the eye; the latter frequently have a semi-sculpted pile and good soft colours, which the Turkish government, who have subsidised a rug-producing enterprise called the Dobag project, guarantees to be the result of the use of pure vegetable dyes only. There are some quite acceptable copies of the bolder Caucasian designs. Say £15 ($25) per square foot.

Ghiordes (*geeordez*), which gave its name to the Turkish knot, is the source of large quantities of silk pieces, commonly

prayer rugs. They vary so widely in quality, from the quite good to the rather bad, that no price guide can be given.

'Art silk' Khayseri are to be avoided except as tourist attractions; the term 'art silk' itself is misleading since the substance from which they are made is actually mercerised cotton, found mostly in lurid colours. They do have a 'glow' or a 'sheen' to them, but closer examination will reveal a lumpy texture and coarse knotting, which you will not fail to distinguish from real silk. The prayer rugs can be bought in most shops for £100 ($160) or so.

Yacebedir and Dosemealti are undistinguished 'commercial' products at the lowest end of the scale for quality, interest and price. Kum Kapu, whose name transliterates as 'gate of sand' which is attributed to the fort of Justinian on the Marmara sea, is a term variously used as one of quality, almost always in silk, but the distinction between these and Hereke is unclear.

Other pieces you're likely to come across include Kula (*koola*) and Melas (*meelas*). The modern Kula are mainly a decor item, useful for apple greens, pale blues, fawns, café-au-lait tones. They are relatively thick, coarsely knotted with a distinctive look of hessian to the back. Rug to carpet sizes, say 5 x 3 feet up to 12 x 9 feet, about £16–17 (c. $26–28) per square foot.

Melas are pleasantly ethnic, the visage frequently displaying a long narrow central field, the stylised totemic 'tree of life' (see Chapter 1). This feature is frequently a sometimes bitter chocolate hue of brown; a distinguishing feature is the use of quite large areas of yellow, from daffodil to vivid canary. Around £20 ($33) per square foot.

From Ushak came rugs that were again depicted in Holbein's work. Currently they are in vogue and pricey. They are coarse to very coarse and drawn from a simple, often crude palette.

AFGHANISTAN

Although mostly quite coarse, some old Afghans have a lot to offer. Good ones have rich, oily wool. In mellow, glowing reds, from ruby to liver in hue, the rugs mostly bear the characteristic imprint of the 'elephant's foot', a bold masculine octagonal gul repeated throughout. For the right sort of dining room (oak-panelled or stone-walled), hall or study, they will cast a pool of warmth on the floor. Thick and tough, and not too expensive, at around £20–40 ($30–60) per square foot in fair to good condition.Modern Afghans all start life in pillar-box red, but a large importer discovered a chemical bleaching technique by which they can be converted to blood orange, brown, tan or gold like a wheat field, depending on the amount of bleach used.These 'commercial' Afghans retail at around £15 ($25) per square foot (available as runners and from 5 x 3 feet upwards to quite large carpets).

Following pages:
Kirghiz nomads
shaking ghilims
outside their
yurt,
Afghanistan.

PAKISTAN

The industry in Pakistan is post-World War II. Having no visual heritage of its own, it looked to the Tekke gul Bokhara for inspiration, copying it in vast quantities and not very well. These pieces do, however, provide a useful range of decor colours from beige, tan, yellow, powder to petrol blue, green, red, tangerine, tomato, 'sweetie pink' through to indigo blue. They are made with industrially produced Merino wool imported from Australia, which gives a remarkably fine, regular appearance to the structure at the back (not really useable as a measure of fineness in terms of knot count because all other rugs are made with wool carded by hand). A special process gives the wool a remarkable velvety sheen. A taste for beginners

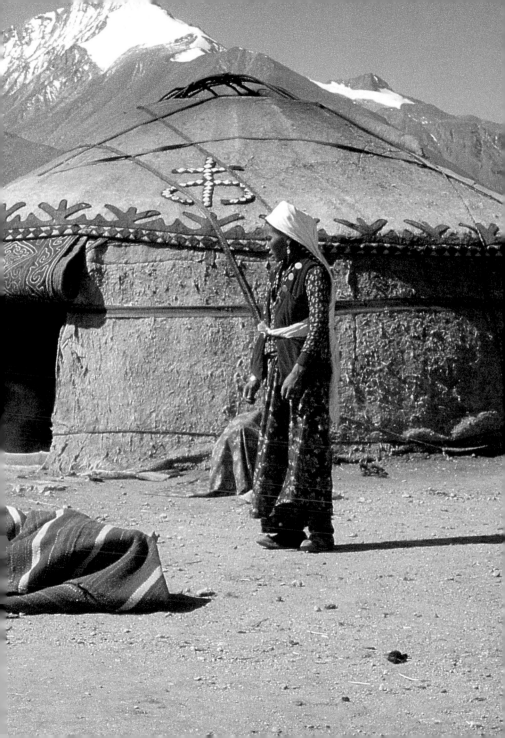

only – very common, rather vulgar. Don't pay more than £12 ($18) per square foot, if you simply must have apple green for the guest bedroom. (These are definitely not for heavy traffic areas like the hall.)

Opposite:
Typical flowery
Chinese.

INDIA

Pakistan and particularly India (Kashmir) are now producing much more ambitious copies of classical Persian pieces, some of remarkable quality and not cheap (you could pay £2000 ($3300) for a good Kashmir silk dozar).

One Indian wool carpet of high quality you might come across is the Agra. The original Agra were made in a prison where, time being no object, some remarkably fine examples were produced in the early twentieth century. The best of Agra can fetch very high prices at auction.

CHINA

Chinese rugs vary in quality from old and good to new and ~mmercial. The older pieces are mostly in blues and beiges, with classi~ ~bols of longevity, dragons and so on.

The new are mostly ~ ~erised by a markedly sculpted pile of different heights, in a flowery .. ᶜ they dare to describe as an 'Aubusson' pattern. They come in coffees, ivo. ~eens, creams, roses. Some found in department stores are covered on the back with a piece of added fabric. This is to prevent those in the know from detecting that they are mechanically produced, or at best 'made by hand' by a man holding a device like a stapler from which he shoots 'knots' into a latex web of warps and wefts. Otherwise only remarkable as a testimony to the taste of their owners, the 'real thing' should cost about £20 ($30) per square foot.

EUROPE

A degree of reverence is due to the antique French Aubusson and Savonnerie factories, who, in the Empire period beginning in the nineteenth century began to produce on a commercial scale carpets and tapestries based on much older Court pieces. They are of considerable delicacy of design (bouquets, garlands, birds) and hue. The softest shell pink, ivories, terracottas and aubergine are predominant. A pure cool blue in the detail is a sure sign of quality. The real thing, 5 x 3 feet, for the boudoir will cost you about £2000 ($3000) upwards; a carpet of 12 x 9 feet, £10,000 ($15,000) upwards. These are very scarce, and attractive as investments. This is definitely an area in which to seek and take professional advice.

Above:
Aubusson.

Ziegler & Co. of Manchester, in the late 19th century, set up manufactories in Tabriz and Sultanabad, which produced 'Persian' carpets designed to Western taste. As a result of this characteristic they are visually pleasing to us and now popular with designers and therefore expensive, although, like Heriz, not of high quality structurally.

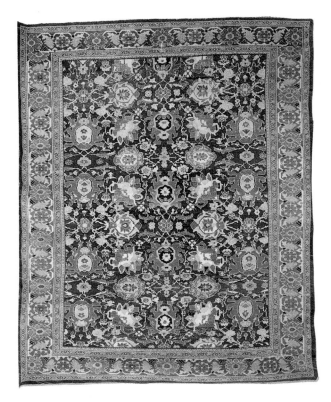

Left: Ziegler (late 19th century).

Doneghals and some carpets by Templeton of Glasgow can be expensive; the Scandinavians produce some wildly abstract, savagely modern things, and certain Spanish sources do some Savonnerie copies, not infrequently as expensive as the real thing.

EGYPT

Egypt has recently re-entered the trade on a limited scale with some really excellent silk pieces based on classical Persian patterns: so excellent indeed that we are afraid they will fool many.

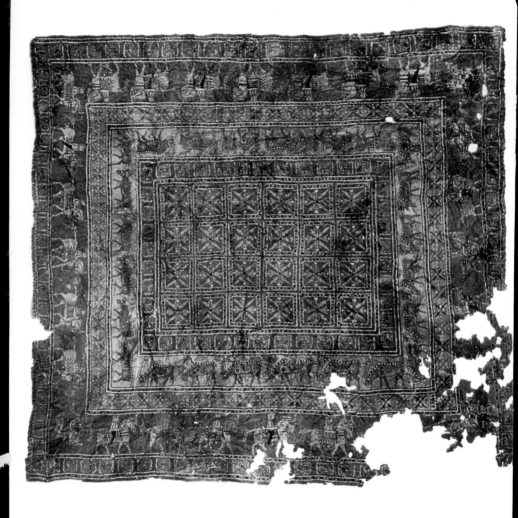

AN HISTORICAL PERSPECTIVE

MILESTONE RUGS

U NTIL the early part of the twentieth century a popular pastime among students of Oriental rugs was to attempt to establish the period of the earliest known examples by reference to their appearance in the paintings of the Italian and Dutch masters of the fourteenth and fifteenth centuries, many notable examples being found in the works of Holbein.

Opposite: The Pazyryk fragment.

This innocent game was brought to an abrupt halt by a Russian anthropologist called Rudenko who, in the late 1940s, discovered in a Kurgan or Scythian tomb in the Altai mountains of southern Siberia, an incomplete knotted rug dating back to somewhere between the fifth and third centuries BC. The textile, which is 90 per cent intact, had been preserved by ice which had formed in the tomb after grave robbers had broken in: the intrusion had inadvertently allowed water to seep in and freeze, providing an important piece of historical evidence, the now famous Pazyryk fragment.

At Bashadar, near Pazyryk, Rudenko subsequently discovered another carpet fragment, said to be older by

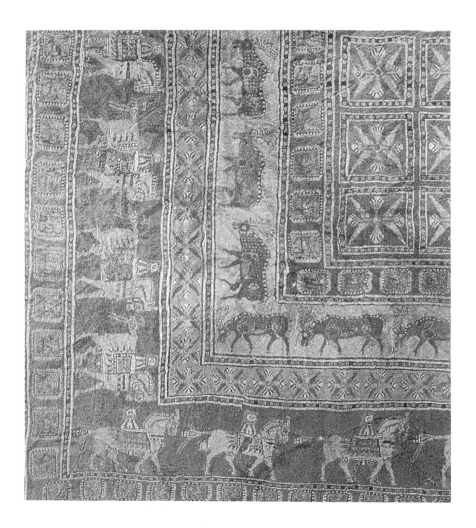

about two hundred years and, interestingly, knotted in the opposite, asymmetrical north Persian knot. The Pazyryk, however, is the generally accepted milestone, providing a wealth of material for scholars.

Opposite: Detail from the Pazyryk fragment.

Measuring six foot eight by six, the Pazyryk was made of wool with the symmetrical or Turkish knotting technique. The visage is interesting in several respects: there are two contrary 'friezes' of animals, one containing twenty-eight stallions, the other twenty-four elk or deer, seven and six respectively to each side of the two squares.

Historical connections are drawn with the twenty-eight peoples or tribes who at that time paid tribute to the Persian ruler Darius, from the Achaemenid dynasty. This tribute was often in the form of gift horses, as shown in a mural flanking the approaches to the Apadana in the Palace of Persepolis, where twenty-eight men support the throne of Xerxes; the Scythians are reputed to have buried seven horses with their chieftains, and so forth. The checkerboard centre may also be related to an ancient Oriental custom of burying people with gameboards among other creature comforts.

The Pazyryk gives a provisional starting point in the study of rugs and carpets, but thereafter their history is disappointingly sketchy until the Middle Ages.

Early literature provides some inconclusive evidence: biblical allusions are interpreted by some as telling us that Paul was a carpet weaver by trade: more concrete references are to be found in Homer but it is not clear what his word '*tapes*' (carpet) means in our terms: the '*tapes*' might have consisted of knotted pile or might not.

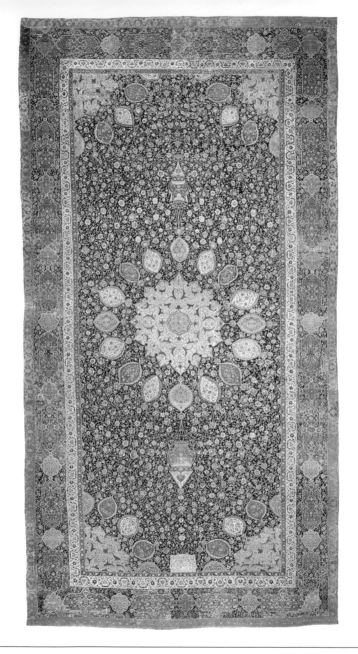

ORIENTAL RUGS

More tangible evidence resulted from excavations made at Lou-lan in East Turkestan in 1920 by Sir Aurel Stein. These produced some fragments dating to the second or third century AD, while others emerged from the Turfan expeditions mounted by the Berlin Museum in 1906.

Opposite: The Ardebil.

THE SPRING OF CHOSROES

In AD 638 the Byzantines conquered King Chosroes II of Persia and found in the palace an enormous 'carpet' known as 'The Spring of Chosroes' measuring about a hundred and thirty by thirty yards, made with silver and gold thread and studded with precious stones. Tragically, this was cut up, divided as booty and lost.

Some fragments excavated in Egypt, and displaying Coptic characteristics, have been attributed to the fifth century AD, and during his voyages in the thirteenth century, Marco Polo wrote that Konya in Turkey was the source of 'the most beautiful carpets in the world'. During the Middle Ages the possession of rugs and carpets by potentates and palaces is amply recorded.

THE ARDEBIL

More recent milestone rugs include the Ardebil, which is in the custody of the Victoria and Albert Museum, and which, helpfully, has its date woven into it, albeit unclearly. The Hejira (Muslim calendar) date converts to either 1522 or 1542. Originally it was thought that this was produced by a man who had fallen from grace in some way and, having

been given sanctuary in the shrine or mosque at Ardebil, devoted himself, as an act of penance or gratitude, to knotting the carpet.

The carpet measures 37 x 17 foot 6 and bears the inscription:

I have no refuge in this world other than thy threshold

There is no protection for my head other than this door

The work of the slave of the holy place Maqsud of Kashan.

A fierce controversy has arisen around this, fuelled by the carpet's background: it was brought to London in the late 1880s by Zieglers, a Manchester carpet company among the first to be active in Persia. A dealer called Robinson then sold it to the Victoria and Albert Museum for £2000 ($3500), a king's ransom in those days. But nobody mentioned to the museum that it was one of a pair.

The 'sister' piece had been 'cannibalised' to restore damaged areas in the one the Victoria and Albert had bought. The remains of the sister piece were donated much later to the Los Angeles County Museum by J. Paul Getty I.

Scholars are having a field day because available records show that no chamber in the shrine at Ardebil was large enough to accommodate one of these carpets, let alone two. Additionally, there exists an inventory of carpets at the shrine dated 1759, in which no carpet of this size is included. It is also, however, a matter of fact that the mosque at Ardebil was the subject of extensive restoration,

so that evidence relating to the size of the rooms may be totally unreliable. But there is another, perhaps more disturbing, piece of evidence: the knot count differs substantially between the sisters, the V&A example having 300 knots per square inch and the one in Los Angeles 400, which to modern scholarship would suggest the hand of a different weaver.

The cause of the argument of course is the question of attribution, because the carpets are certainly not Ardebil. Ardebil rugs have been made for centuries and are tribal in character. The V&A Ardebil is either Tabriz or Kashan. I for one see no reason to doubt that 'Maqsud of Kashan' knew where he came from. And in the end the work speaks for itself – wherever it was made, it is a work of master craftsmanship, and we are lucky to have it, even in 'mutilated' form.

THE 'CHELSEA' CARPET

The late nineteenth century must have been an active period for the custodians of our rug heritage, because in 1890 they spotted and purchased another milestone carpet, known as the Chelsea Carpet, but no more made in Chelsea than the Ardebil was made by Ardibilian hands. Attributions vary hugely and may be summarised as 'central Persian'. It is called the Chelsea Carpet because it was spotted and bought in the King's Road, Chelsea. Dating to the sixteenth century, it measures 17 foot 9 x 10 foot 4 and was purchased from one Alfred J. Cohen, furniture dealer of 189 King's Road, for the slightly more modest sum of £150 ($225).

Both the Ardebil and the Chelsea belong to the period often referred to as the 'Golden Age' of carpet production: under the Persian Safavid dynasty (1501–1736) all forms of art flourished and prospered, including weaving; several hundred master works have survived from these times.

The golden age in Persia was abruptly terminated by the Afghan invasion in the early eighteenth century and rug production virtually ceased in important centres such as Kashan and Ispahan, not to be resumed until the late nineteenth century. This yawning gap is largely responsible for the extreme scarcity of really old classical pieces of the highest quality, outside of museums and a very few private collections.

WESTERN EXPOSURE TO ORIENTAL RUGS

Oriental rugs and carpets were not in general circulation in Europe until the late nineteenth century. Holbein mostly showed them not on the floor but as table coverings: a few were used as hangings but their presence seems to have been limited to courts and palaces.

Not until around the turn of the twentieth century did popular demand really arise in Europe and when it did the impact on production was disastrous. The suddenly increased demand was met by craftsmen taking short-cuts. The notorious 'double knotting' to increase speed of production, and the use of chemical rather than home-

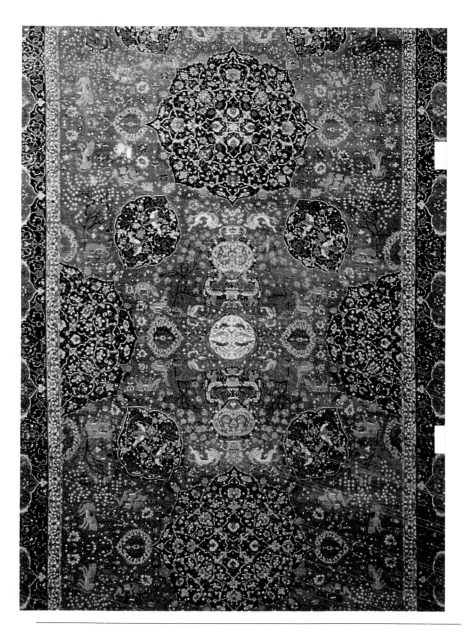

made natural dyes, which attacked the wool, resulted in a considerable reduction in quality.

Elsewhere, the earliest evidence of hand-knotted rugs and carpets comes from Egypt, where fragments found in Fostat date back to the nineth century. The technique used in making these, however, was primitive and the results poor. A better product emerged in the fifteenth and sixteenth centuries, using the asymmetrical or Persian knot.

These are referred to as Mamluk, after the Sunni descendants of the Seljuk Turks: references in contemporaneous Venetian trade inventories to *tapeti damaschini* are now thought to be descriptive of the material used rather than suggesting that they originated in Damascus where, so far as is known, no rugs were produced.

Production continued during the Ottoman era but appears to have declined and died out by the eighteenth century. Today there is something of a resurgence, and copies of classical patterns, mostly Persian, are of very acceptable quality, especially in silk.

In India, under the Moghul empire from the mid-sixteenth century, Persian rugs and carpets were imported and indeed so were craftsmen capable of making them. Several production centres were set up, notably in Agra (see Chapter 7). During the nineteenth century production was of a high standard. The blight that fell on quality at the turn of the century, however, has never really been shaken off and India is today mainly a source of low-quality 'commercial' goods of little intrinsic value, with the exception of certain Kashmiri silks.

Opposite: This breath-taking Savonnerie is the world record holder for price. It was sold at Christies in London on the 9th June, 1994 for £1,321,500. It is Louis XV, emblazoned with the Royal Arms of France and measures 6.03m x 5.67m. It was bought for the Riahi Collection, Paris.

China, curiously, appears to have been a late starter.
Other than the fragments found at Lou-lan, about whose
origin there is considerable doubt, there is no record of
production earlier than the end of the seventeenth century.
Certain pieces, notably the interesting pillar rugs,
particularly of the late nineteenth century, are sought after,
and the older pieces naturally reflect their creators' love of
the visualisation of symbolic abstract concepts (signifying
long life, happiness and so on). Contemporary production,
however, is strictly in the 'polychromatic floor covering'
league.

In Europe, the Arab conquest of Iberia resulted in some
production of knotted textiles, and there is a record of
Spanish carpets decorating the court of the Caliph in Cairo
in the twelfth century. These were made with the 'Spanish'
knot, a variation on a single loop technique which might
well have been implanted by the Moors; it is similar to the
work of Arab weavers of the nineth century.

By the twelfth century there were many looms in
Almeria and active production centres in Alcaraz, Cuenca
and Valencia, although in Valencia the technique was
Turkish. But if the structural techniques were imported,
the patterns were not: designs were markedly European
rather than Oriental, frequently floral or armorial.

In France, a workshop was established under royal
patronage in the first half of the seventeenth century, firstly
in the Louvre and latterly in a former soap factory whence
emanated the famous Savonnerie. Although the original aim
of this project was to produce carpets '*à la façon de Perse et*

du Levant the actual output had a style of its own which was unmistakably European, formal and totally symmetrical.

These were piled carpets, but at about the same time the Gobbelin and Aubusson tapestries and carpets were developed and commissioned to adorn the Palace at Versailles. These again were strictly European in visual character, and indeed the Aubusson pattern has, uniquely, been copied by some weavers of the Orient, under Western motivation.

BUYING ORIENTAL RUGS FOR EVERYDAY USE

BUYING FROM SHOPS

THERE is no substitute for practical experience if you really want to achieve a worthwhile degree of knowledge. By far the most useful thing you can do is to befriend a local specialist retailer of rugs. 'Local', you may well find, is not too easy: but unless you live in a really remote, rural situation or in the outback there should be one within a reasonable radius.

Opposite: A stall at the Khyber Pass market, Pakistan.

And note the word 'specialist'; the sort of underpaid, overworked assistant found in all but a handful of department stores won't do; such half-digested information as he or she may have, coupled with misguided sales patter, will only serve to lead you astray. A well-established specialist shop, which will almost certainly be staffed, at least part of the time, by the owner, is ideal. Wander around, handle a few rugs, and imbibe the atmosphere until a suitable opportunity presents itself.

When you get your opportunity, tell the owner frankly that you've come to pick his or her brains. Explain that you're just a beginner but that you do expect to buy some rugs (although

not necessarily on that particular day). Most people love to have their brains picked, especially if they think there may be a sale at the end of the trail. But your approach is important. Don't, for example say, 'How do you know that's a Hamadan?'. You want to know what a Hamadan looks like. He knows because he's dealt with hundreds of them over the years; the question is, 'How can I learn to know a Hamadan from something else; and how can I tell a good one from a not so good one?'

And, if, during an early visit, you see something that appeals to you and doesn't cost an outlandish sum in relation to your means, buy it. The retailer's favourite student is not the sort who comes in once a month for years and never spends a penny.

And besides, one of the best ways of getting to know about rugs is to live with one; you have to start somewhere.

The next time you go in, you can casually remind the owner that you bought a piece there not long ago. If it is a reasonably active shop, it will be worth your while to go in at least every couple of months because there will be new things to see, and seeing them in the flesh is infinitely more worthwhile than only reading about them or looking at pictures.

The visage, remember, reveals only part of the character and identity of the piece. Go carefully through the piles: compare like with like. Finger and handle a couple of dozen Belouchi. Stare at the backs, and you will begin to see the family characteristics: your visual memory will develop muscles only with exercise, and before long you will develop more knowledge, and with it more confidence.

Serious students and lovers of Oriental rugs will find that

often the rugs they have bought have been purchased because they simply couldn't resist the piece – it spoke strongly to them in some coded communion.

It is not a bad idea, however, especially for beginners, to have some specific purpose in mind, to set out to buy a piece to fulfil a specific function in the home. This helps to keep your mind clear when faced with the *embarras de richesses* that is likely to confront you at even a moderately well-stocked shop or warehouse.

Look for quality. Fitting the rug aesthetically into your home is important but not all-important. Don't forget to compare like with like. When buying a Belouchi, for instance, sort out three or four that have the right sort of colours. Study and compare the backs of the rugs: they'll all be fairly coarse and lumpy, but they can vary quite a lot: the less lumpy and the tighter the knotting, the fewer and thinner the weft shoots the better. And keep an open mind: if you've budgeted to spend £150–200 ($250–330) on a Belouch to give a warm glow in the study, don't pass up a nice old Bokhara at £300 ($500). It may well be three times the rug for twice the price.

TRY THE GOODS AT HOME
Oriental rugs react very much to lighting and colour context, and will look very different at home. Any reputable dealer will be delighted to let you try one or two at home for a few days before you commit yourself. You want time to get past the staring stage; let the rug assimilate itself into the background, see it out of the corner of your eye as you pass by, in morning light, in evening light, in sunlight and shade, in lamplight and so on.

Don't pay too much attention to well-meaning relatives who say it's too blue or too 'busy', or to the man next door who says he's an expert and tells you you're being robbed. Make up your own mind – if it gives you pleasure now it will continue to do so.

WHICH RUG GOES WHERE

If you have decided that you're looking for something for the hall, arm yourself with the maximum and minimum measurements that will do the job. This gives you a size bracket to work within and it will also help you to form some idea of a budget price.

If, in your home, the 'hall' is a flagstoned lobby bearing constant heavy traffic of muddy boots and dogs, you'll probably be looking for an Afghan or maybe a cheap and cheerful Hamadan, and you should expect to pay around £10–15 ($15–25) per square foot. If, on the other hand, your 'hall' receives only occasional caresses from Gucci shoes and satin evening slippers, and is rectangular rather than long and narrow, then you'll want a classical Persian with a formal central medallion (echoing the chandelier) and a big price tag.

If your rug is for hanging, look out for old pieces too worn to be used on the floor. Good tribal pieces, not in the best state of repair, can be a cheap but effective solution, given sympathetic lighting, and of course prayer rugs, having a top and bottom, make visual sense as hangings.

For the dining room, choose something with an overall pattern such as Ferraghan or Serabend or a warm Afghan or

Turkoman (it would be a shame to cover a carpet with a glorious central medallion with a dining table). One particular merchant, on hearing that an important customer was proposing to buy an exceptionally beautiful Ispahan with a gracious central medallion – at about £33,000 ($55,000) – to put under his dining table, informed the customer quietly but resolutely that the piece was no longer for sale.

When taking measurements for a dining room it is important to allow for the length and width of the table plus at least three chair depths at each side and the ends, so that chairs can be pulled out and in without irritatingly catching the edge of the carpet all the time.

For the fireside, your first consideration must be the type of fire you have. If it spits ill-tempered sparks from time to time you will have to get a proper screen if you're going to put a decent rug there. Oriental rugs on the whole are unlikely to catch or even encourage a real fire: they tend to smoulder only. But holes are expensive to restore properly, and it follows that the better the rug the more expensive the restoration. If on the other hand, you want nothing to come between you and your logs, buy a cheap Belouch that you don't have to worry about.

People frequently ask where silks can be used. The answer generally is that they should be hung. But of course they can go on the floor in a little-used drawing room or in the bedroom. Formal city pieces suit formal drawing rooms; tribal pieces are best for folksy, comfortable rooms.

For general purposes, most durable are the leathery Persians like Sarouk, or the 'iron' Bidjar, or Turkoman. Least durable are Pakistan, basically a decor item.

Modern kitchens, often quite large and quite possibly doubling as a living area, present special problems. Consider ghilims: they go well with quarry tiles or pine, and, foot for foot, are much cheaper. But they do tend to be lightweight and kick up or slide: make sure that you have an underlay that prevents this and don't put your ghilim underfoot by the cooker – far too dangerous for unsuspecting feet.

BUYING AT AUCTION

EXAMINE THE GOODS

You wouldn't believe how easy it is, even after years of experience, to get carried away by a pretty face, only to find ragged or damaged skirts, selvedges and other problems on closer inspection.

Even at reputable establishments, be aware that the catalogued descriptions and attributions may be over-generalised, or even wrong. Oriental rugs are still something of a closed book to all but the most specialist rug auctioneers. Try to form your own opinions, and don't get involved with big prices unless you're confident that you've graduated, or can get advice from a specialist for which you can pay a small fee.

- Allow plenty of time for viewing; if the piece you're interested in happens to have a ten ton sideboard sitting on one end, insist on having it moved. It may well be, and has been known to happen, that the sideboard is sitting on top of a hole, or at least an area of excessive wear.

- Ask a porter to hold the piece up to a strong light. Look for holes or thin areas where the light will shine through.

- First look at the ends and edges – do they wave around? They'll never run like the edge of a ruler in a hand-made article, but the less erratic they are the better; if choosing between two comparable pieces, choose the straighter.

- Lay it flat on the ground (and don't be put off or embarrassed if it's difficult to find an area big enough to do this – find one!). A good rug always lies flat; lumps and bumps are signs of poorly tensioned knotting, and will sooner or later wear unevenly.

- If the ends and selvedges are distressed, don't worry too much unless the end has eroded right into the body of the rug, and there are parts missing; these can be attended to relatively cheaply (say £50–100 ($80–150) for a 6 x 4 feet piece).

- On the face of an old rug evenly dispersed wear is obviously to be expected. But beware if there are small areas of extreme wear or actual holes. These are only to be dealt with by proper and expensive (several hundred at least) restoration by experts and such expenditure is not likely to make economic sense in relation to the value of the piece unless it's extremely valuable or rare.

- Get on your knees and give it the fingertip test. Teach your eyes and your fingers to watch for 'painting'. Areas of wear are sometimes masked with a battery of felt-tip pens, restoring the colour to the worn parts. The pens produce a distinctly flat or matt hue, and a matted, slightly tacky texture to the rug, which your fingertips will detect. The pile height should be even, consistent, except in older pieces where any area that was originally black may have a noticeably sculpted effect because the iron oxide they used to make the black corrodes the wool after thirty to forty years. Watch out for areas of moth attack.

- Watch out for 'shrook'. This trader's term is onomatopoeic for the sound the rug makes if it's 'cracking'. Take a handful of weft, leave a hand's breadth, and grip another handful with the other hand. Wobble it gently, then tweak firmly, near your ear. If you hear a dry cracking sound, retreat with wallet intact. The 'shrook' condition arises when all the oil has dried out of the wool: the rug disintegrates and there is no known cure. It is mostly found among the finer old Persian tribal pieces such as Senneh, but almost any rug can contract the disease – often as a result of having gone through extreme changes in climate.

- Watch out for 'colour run'. Even good pieces can suffer from this at some time for one reason or another. Look at areas where pale white or ivory sit next to strong colours like navy or red. Any tingeing of the pale colour by the strong reduces the value of the piece considerably.

BIDDING IN PERSON

Station yourself where you can see all or at least most of the room; don't become mesmerised by the auctioneer. You don't need to look at him; it's his job to watch you. You can hear him, and you don't have to see him. But you do want to see who else is bidding, to be sure that you're not bidding against yourself or the 'wall'. Don't bid too fast. 'Come on, ladies and gentlemen, let's get on with it,' is a favourite cry, but don't allow yourself to be rushed. Hesitate; be doubtful, tentative. An experienced auctioneer knows that a quick eager bidder will go a good deal further, and increase the size of the bidding steps. You can overcome this trick by speaking your bid clearly and after you've hesitated. If the last bid was 75 and you say 80, you've upped the bid by 5; if you nod, the auctioneer might say 100 and you've upped the bid by 25. Leave the nods and winks to the professionals.

Another point about bidding to bear in mind is that you don't have to think in round numbers, for example 'I'll go to 50 or 100'. This creates psychological barriers, often with the result that the tiro drops out at 100, only to be defeated by a professional at 105. So if you're leaving a bid, say, '100 plus one bid'.

LEAVING BIDS AT AUCTIONS

Before using this facility, i.e. leaving instructions for the 'house' to bid on your behalf, you must enquire as to how this system works. There have been cases at country auctions where, someone having left a bid of say 100 with the house, the auctioneer has started the bidding at that price. This is quite improper, of course, but bidders should be aware that it can happen.

Buying at 'auctions' held in hotels and other unusual places

The main characteristic of people you meet in hotels is transience, and that is the last thing you are looking for in someone from whom you're going to buy anything costing a significant sum of money. Quite a few hotel 'auctions' are no such thing; the audience is seeded with 'bidders' who cleverly raise your last bid as long and as high as they think you'll go. They may also be somewhat economical with the truth when describing the goods at times: 'a Pakistan bokhara in mint condition' might seem to suggest an original of some sort in good condition when, in fact, it's brand new!

Buying at 'Source'

I often come across people who say, 'Look what I bought in Tehran/Istanbul/Calcutta for only X amount.' The figure in question is invariably more than they would pay at home, even allowing for tax. Of course you can sometimes buy some pieces more cheaply abroad, if you know what you're doing, but not often.

INVESTING IN RUGS

Certain traders, myself included, operate a service whereby they will escort you to the trade's London warehouses, where they will introduce you to merchants whose families have been in the business for generations. (These warehouses are not to be confused with those advertised in the press, which are retail organisations using the term 'warehouse' to attract members of the public who think they're getting on to an inside track.)

At genuine warehouses, with a good broker to guide you, you will get on the inside track and will find both stock and prices that no retailer could compete with. For serious buyers, looking for genuine antiques for instance, it's the only way to get a real depth of choice.

Serious traders and investors alike should have various criteria when considering Oriental rugs. The answer to the question 'Are Oriental rugs really a good investment?' can only realistically be 'It depends'. If you are looking for cashable capital appreciation next year, look elsewhere. But if you have in mind the middle to long term, say ten years forwards, it is a field well worth investigation. Over this sort of period, the least any self-respecting rug will do is hold its value against the rate of inflation, so you always rely on a firm 'bottom-line'.

Beyond that, the answer, once again, is 'It depends': it depends on what you buy, how well advised you are, where you buy, when you buy (i.e. how lucky you are with your timing).

The issue of timing is important: movements of taste and fashion come into play with Oriental rugs just as they do in other fields of art, the timing or direction of which no one can predict. In the late 1960s and 70s for example, people tended to go for the sexy, glamorous silks, the 'ooh-ah' sort of rug which, thanks to the advanced state of the art, palpably glowed with luxury, quality and value, notwithstanding the fact that many of them were not particularly old.

It is currently the more ethnic types that are sought after – Caucasians, Turkoman and the rarer of the tribal pieces from Iran. These pieces, in good condition, are in genuinely short supply, and thus in the 1990s a high degree of demand has coincided with a low level of supply, pushing prices up as a result by as much as 100 per cent in ten years.

And some have done much better than 100 per cent: a large Heriz carpet, for instance, which ten years ago might have been found for around £2–3,000 (($3000–5000), and which during the intervening period could have graced your hall or dining room while its patina improved with age, would now be hard to find at £10–15,000 ($15,000–23,000).

No matter what happens, in financial terms however, as an investor you will receive a secure, lasting and growing dividend: the pure spiritual pleasure of living with your rugs.

What to Buy

We are frequently asked 'Which are the best?' or, 'What should I buy – Persian, Russian, Chinese...?' This is an impossible question to answer as it's all very much a matter of personal taste. The 'best' rugs from the standpoint of the highest quality of knotting and physical structure would be Persian 'city' pieces like Ispahan, Nain or Kashan but the good ones command high prices. Some of the Persian tribals like Senneh or Sarouk; some Turkoman would also be in this league for inherent quality but a little cheaper.

Caucasian, the most rapidly appreciating of all in recent years, are perhaps an acquired taste. Some people react favourably to them at once, others seem to 'grow' into them. From a decor point of view they are rather demanding; there are certain contexts in which they are quite stunning and others in which they might be considered too stunning. Mostly they will involve a fairly serious outlay, so this is definitely an area in which to seek expert guidance. Particular care should be taken over the condition of such pieces: go over a prospective purchase inch by inch, both front and back (damage and repairs are easier to spot on the back). Although loosely knotted and therefore theoretically easier and quicker to repair, no proper restoration in the body of the rug is cheap these days.

LIVING WITH
ORIENTAL RUGS

NATURALLY most people want to create a
harmonious environment by choosing a rug
that matches the rest of their décor. It is not,
however, something by which to set too much store. One
case comes to mind of someone who insisted on finding a
rug featuring the exact colour of their fitted carpet. By
some miracle I found one, but it turned out to be a
disaster, because where that colour appeared, in three
central medallions, it looked like the rug had three holes in
it, showing the carpeting below!

By contrast I once visited a house with a large L-shaped
library, in which every inch of the floor was covered in
Oriental rugs of all types, ages, colours and conditions. It
broke every rule in the interior design book, but it did look
wonderful!

The main thing about living with Oriental rugs is the
enjoyment. When you look at the face of one of these old
friends you will often see features you've never noticed
before. They're like that; the longer you live with them, the
more they continue to please and surprise you.

CARE AND MAINTENANCE

Contrary to what you may be told, Oriental rugs will not last for ever. It stands to reason, particularly since they were never intended to be walked upon with shoes, any shoes, let alone high heels on a parquet floor. (The weight an average woman puts on a stiletto heel – pounds per square inch, is the same as the weight an elephant puts on each hoof!) Your rugs will, however, last a long time, even several generations, if you take proper care of them.

- If one or more of your rugs lives in an area of heavy traffic, turn them around from time to time, so that the wear is shared by different parts. And give them a year off occasionally by moving them to less busy areas of the house. It is so sad to see fine pieces in which limited areas are excessively worn while the rest is pristine.

- Watch the edges and the selvedges; if they show signs of distress, have them secured. Don't attempt to do this yourself if you can help it. If you must try, use stitches so that your work can be undone if necessary; never apply any sticky tape or other types of adhesive, because over a period of time these substances harden and make the textile impossible to deal with properly.

- Don't use a vacuum cleaner on your rugs. Take them up and shake them outside once a week. Put them face down on the lawn or hang them over a rope and beat them firmly (not

violently) on the back with a cane beater once a quarter, and have them professionally cleaned every five years or so.

- If your rugs skid around and misbehave, rumpling up all the time, there are man-made materials you can buy to lay underneath to hold them in place; don't let them irritate themselves and you by being a nuisance.

DISASTERS

If someone throws a glass of wine across your favourite rug, don't panic. The chances are that if you leave it till the morning you wouldn't even be able to see where the wine landed. But if you are particularly concerned, squirt a tiny amount of soda water on the area and dab with a rag or paper towel. Watch closely as you do this: if a lot of dye comes off on your rag, stop and take the rug to your specialist as soon as possible.

INSURANCE

- Make sure your cover is adequate and index-linked.

- Keep all invoices for your rugs as a record of what you purchased, where and when.

- Take (or have taken) some photographs of your rugs which should be kept out of the house, perhaps at the office, your

bank or at your solicitor's office. It is unusual for Oriental rugs to interest burglars, but by no means unheard of. In a recent break-in at a house containing about twenty Oriental rugs, the three best rugs were taken and nothing else – not even the silver.

- If you do lose a rug, you will have to establish its value; photographs will help, but your specialist will not be 100 per cent happy giving a valuation based on pictures alone. You should, therefore, have your rugs valued, every five years or so.

If you have the builders or painters or telephone man in, it might be better not to say things like 'Mind your feet', or 'Watch out for that rug, it's valuable'. Remove it in advance, or ignore it.

STORAGE

- Don't fold your rugs into bundles; roll them. It is a good idea to roll them around a cardboard tube or wooden pole.

- Professionally clean and moth-proof your rug before storing, then roll it and wrap in cotton followed by plastic.

- Seal the ends in the summer months against moth, but open them to admit air in the winter.

- Store in a cool, dry, vermin-free place, and check at regular intervals.

COLOUR	AFGHAN	AFSHAR	AGRA	AUBUSSON	BACHTIAR	BELOUCH	BIDJAR	BOKHARA	CAUCASIAN	CHINESE	DONEGHAL	EZINEH	FARS	FERRAGHAN
RED	•	•			•	•	•	•	•					•
TERRACOTTA	•			•		•		•				•		
PINK/ROSE	•			•	•	•		•		•		•		•
BROWN/COFFEE	•			•						•			•	
FAWN/BEIGE	•		•	•		•			•	•			•	
CREAM/IVORY				•	•		•			•			•	
YELLOW/GOLD	•		•		•					•	•			
GREEN									•		•	•	•	•
TURQUOISE												•		
BLUE		•			•	•	•		•	•		•		•
PALE BLUE					•		•		•	•	•	•		•
PURPLE/MAUVE				•		•								
ORANGE	•				•	•								

HAMADAN	HERIZ	HEREKE	INDIAN	ISPAHAN	KARS	KASHAN	KERMAN	KULA	KURDISH	MELAS	NAIN	PAKISTAN	QUASGAI	QUM	SENNEH	SHIRAZ	TABRIZ	TURKEY
•				•		•	•					•		•		•		•
•	•				•		•						•	•	•		•	
•	•			•			•						•	•	•	•	•	
		•			•		•	•		•	•			•				
			•	•			•	•		•	•							
			•	•		•	•	•				•	•	•				
	•		•	•						•		•	•	•				
					•	•	•	•		•		•		•				
					•		•					•		•				
•					•	•	•	•	•		•	•				•		
•	•				•	•	•	•	•		•	•	•	•	•	•	•	
							•											
					•				•									

Picture Acknowledgements

We wish to express our thanks to the following sources:

Ivan C Neff Esq, Cape Town.
Joseph Lavian, London.
Eastern Kayam OCM Limited.
Jay Jones Esq, California.
Teppich Engelhardt, Mannheim.
Patrick Collins Esq, Bristol.
Penguin, London.
Cyrus Carpets, London.
PRJ Ford Esq and Thames & Hudson, London.
The Hermitage Museum, St Petersburg.
Allen & Unwin, London.
Einrichtingshaus Böhmer, Munich.
David Black Esq, London.
Stenstroms Bokförlag AB, Stockholm.
Christies, London.
The Victoria and Albert Museum, London.
Sotheby's, London.
Reinhard G Hubel Esq, Berlin.
Vsesojuznoe Obednenie Mezhdunarodnaya Kniga, Moscow.
Hali magazine, London.
Mrs K McDaniel, Bath.
Ferndale Editions/Quarto Publications.

The Hutchison Picture Library
p6 ©Emile, 10 ©Andrey Zvoznikov, 32, 42-43 ©Disappearing World, Granada TV,
46-47 ©Jeremy Horner, 48 ©Tony Souter, 118-119 ©Trevor Page,
158-159 ©Disappearing World, Granada TV, 176-177 ©Disappearing World, Granada TV
and 196.

Maps by Arcadia Editions.

Bibliography

BENNETT, Ian, *Book of Oriental Carpets & Rugs*. London, Hamlyn 1972.

BENNETT, Ian, *(Ed.) Rugs & Carpets of the World*. London, Ferndale/Quarto 1981.

BLACK, David and LOVELESS, Clive, *Rugs of the wandering Baluchi*. London, David Black Oriental Carpets, 1976.

BODE, W. Von and KUHNEL, Ernest, *Antique Rugs from the Near East*. (Eng) London, 1970.

EDWARDS, A. Cecil, *The Persian Carpet*. London, Duckworth 1953.

EILAND, Murray L., *Oriental Rugs, a complete guide*. Greenwich, Conn. New York Graphic Society 1973.

ERDMANN, Kurt, *Oriental Carpets*. (Eng) London, Zwemmer.

ERDMANN, Kurt, *Seven Hundred Years of Oriental Rugs*. (Eng) London, Faber 1970.

FORD, P.R.J., *Oriental Carpet Design*. London, Thames & Hudson 1981.

HOUSEGO, J., *Tribal Rugs*. London, 1978.

HUBEL, Reinhard G., *The Book of Carpets*. (Eng) London, Barrie & Jenkins, 1971.

MUMFORD, J.K., *Oriental Rugs*. New York, Charles Scibner's Sons 1900.

NEFF, Ivan C. & MAGGS, Carol V., *Dictionary of Oriental Rugs*. Ad Donker Johannesburg, 1977. (This was a ground-breaking publication, now sadly out of print, but the author has a few copies left.)

OPIE, J., *Tribal Rugs of Southern Persia*. Portland, 1981.

SCHURMANN, Ulrich, *Caucasian Rugs*. (Eng) London, George Allen & Unwin.

INDEX